Contents

Julieta Aranda, Brian Kuan Wood, Anton Vidokle
What Is Contemporary Art?
An Introduction

What is contemporary art? First, and most obviously: why is this question *not* asked? That is to say, why do we simply leave it to hover in the shadow of attempts at critical summation in the grand tradition of twentieth-century artistic movements? The contemporary delineates its border invisibly: no one is proud to be "contemporary," and no one is ashamed. Indeed, the question of where artistic movements have gone seems embedded in this question, if only because "the contemporary" has become a single hegemonic "-ism" that absorbs all proposals for others. When there are no longer any artistic movements, it seems that we are all working under the auspices of this singular -ism that is deliberately (and literally) not one at all ...

Widespread usage of the term "contemporary" seems so self-evident that to further demand a definition of "contemporary art" may be taken as an anachronistic exercise in cataloguing or self-definition. At the same time, it is no coincidence that this is usually the tenor of such large, elusive questions: it is precisely through their apparent self-evidence that they cease to be problematic and begin to exert their influence in hidden ways; and their paradox, their *unanswerability* begins to constitute a condition of its own, a place where people work.

So it is with the contemporary: a term we know well enough through its use as a de facto standard by museums, which denote their currency through an apparently modest temporal signifier: to be contemporary is to be savvy, reactive, dynamic, aware, timely, in constant motion, aware of fashion. The term has clearly replaced the use of "modern" to describe the art of the day. With this shift, out go the grand narratives and ideals of modernism, replaced by a default, soft consensus on the

immanence of the present, the empiricism of *now*, of what we have directly in front of us, and what they have in front of them over there. But in its application as a de facto standard, this watery signifier has through accumulation nevertheless assumed such a scale that it certainly *must* mean something.

If we pursue it further, however, and try to pin it down, it repeatedly escapes our grasp through a set of evasive maneuvers. And perhaps we can say that the -ism which is *not* is *evasive maneuver number one*: the summation that does not admit to being critical or projective (in the grand tradition of modernist ideological voices), to denoting an inside and an outside, a potential project, but is simultaneously *there*, saying nothing. So why the extra qualifier? Why insert an extra word into "museum of art"? Like any evasive maneuver, this one works by producing a split: between the term's de facto usage, which momentarily holds your attention by suggesting the obvious parallel with "current," with its promise of flexibility and dynamism, while simultaneously building a museum collection along very specific parameters—masking ideology. To follow the self-evidence of the question at hand, we could note the morphological Frank Gehry walls of a spectacular contemporary museum to be in fact made of concrete and steel—their suggestion of formless flexibility, their celebration of the informal, is frozen in some of the heaviest, most expensive, and burdensome institutional public sculpture around. The contemporary suggests movement, yet itself does not budge.

This contemporary museum is acutely aware of other contemporary museums in other places. It is a node in a network of similar structures, and there is a huge amount of movement between them. *Evasive maneuver number two* could be the one that

shifts your focus to a presumably de-centered field of work: a field of contemporary art that stretches across boundaries, a multi-local field drawing from local practices and embedded local knowledge, the vitality and immanence of many histories in constant simultaneous translation. This is perhaps the contemporary's most redeeming trait, and we certainly do not miss the old power centers and master narratives.

In many ways, this is an evasive maneuver worth making. And we can even avoid the conservative critique that such horizontal movement cheapens what it encounters, reducing it to spectacle. Certainly the quantity of work placed on display can become an issue, but networks now spread much wider than ever before—much has been made available, and it is up to you to sort through it. The contemporary as a cacophonic mess gives us enormous hope.

But let's not underestimate how the contemporary art system can atomize with some degree of cohesiveness. True, many peripheries have been mobilized not as peripheries, but as centers in their own right. But, seen from the so-called peripheries and centers alike, does this system really learn, or does it merely engage with its many territories by installing the monolithic prospect of hyperspectacle? If we are indeed aware that something is lost and something is gained in any process of translation, are we as certain that the regime of visibility installed by contemporary art functions by placing various local vernaculars into contact with each other on their own terms (as it promises to do), or is it something like the international biennial circuit, asserting its own language distinct from center and periphery alike?

In this way, the contemporary starts to reveal itself to be something like a glass ceiling, an invisible barrier that seals us together precisely by its very invisibility. We acknowledge one another, individual artists, certain cities, social scenes, a few collective tendencies that seem to arrive more as common interests than social projections, but nothing attains critical mass under any umbrella beyond "the contemporary." It's not so different from how we understand capitalism to work, through one-to-one relationships that are seemingly too small-scale to be complicit with anything, masking the hidden ultimatum of an innocuous protocol— if we begin to discern its shape, either it shifts, or we become obsolete: *uncontemporary*. But then perhaps that would not be such a bad thing . . .

This book began as a two-part issue of *e-flux journal* devoted to the question "What Is Contemporary Art?" as it was addressed in a public lecture series of the same name organized by Anton Vidokle at ShContemporary, Shanghai in September 2009. Special thanks go to Colin Chinnery, Liam Gillick, and all the contributors: Zdenka Badovinac, Hu Fang, Hal Foster, Boris Groys, Jörg Heiser, Carol Yinghua Lu, Cuauhtémoc Medina, Hans Ulrich Obrist, Raqs Media Collective (Jeebesh Bagchi, Monica Narula, and Shuddhabrata Sengupta), Dieter Roelstraete, Martha Rosler, Gao Shiming, and Jan Verwoert.

Cuauhtémoc Medina
Contemp(t)orary: Eleven Theses

1.

It would appear that the notion of "the contemporary" is irredeemably vain and empty; in fact, we would not be entirely mistaken in suspecting "contemporary art" to be a concept that became central to art as a result of the need to find a replacement, rather than as a matter of legitimate theorizing. For above all, "contemporary" is the term that stands to mark the death of "modern." This vague descriptor of aesthetic currency became customary precisely when the critique of "the modern" (its mapping, specification, historicizing, and dismantling) exiled it to the dustbin of history. At that point, when current art lost the word that had provided it with a programmatic stance, chronological proximity became relevant—even if it did not indicate anything of substance. To be sure, "contemporary" fails to carry even a glimmer of the utopian expectation—of change and possible alternatives—encompassed by "the new."

2.

Nothing would seem to so eloquently suggest the lack of substance in "contemporary art" than the facility with which it lends itself to practical adjustments. Museums, academic institutions, auction houses, and texts tend to circumvent the need to categorize recent artistic production by declaring the "contemporariness" of certain holdings or discourses on the basis of a chronological convention: the MOCA in Los Angeles takes into account everything made "after" 1940; the contemporary holdings of Tate Modern in London were all created sometime after 1965; Kristine Stiles and Peter Selz's sourcebook *Theories and Documents of Contemporary Art* takes 1945 as its starting point. In other contexts—particularly on the periphery—the

horizon of contemporaneity tends to be narrower, usually defined as appearing in the early 1990s and associated with the rise of the postcolonial debate, the collapse of the Euro-American monopoly over the narrative of modernism, or the end of the Cold War. In any case, "contemporary art" appears to be based on the multiple significance of an "after."

3.

However, as is usually the case with chronological categories, this neutrality may soon unfold into a noun with a certain substance. As with "the modern," it would not be hard to imagine "the contemporary" one day becoming oxymoronically fixed, specified, and dated as the signifier of a particular shift in the dialectics of culture. There are at least two senses in which the contemporariness of artistic culture involves a poignant turn. There is the blatant immediacy of the relationship between a contemporary practice and its host society, and then there is its integration into a critical apparatus.

Never since the advent of historical relativism at the end of the eighteenth century has the art of the day had a less contentious social reception. Claims concerning the esoteric nature of contemporary art in the West mostly derive from the density of theoretical discourse on the topic—discourse that actually operates on the basis of practices that involve a certain level of general legibility. It may well be that one of the main characteristics of contemporary art is to always demand, at least, a double reception: first as part of general culture, and later as an attempt at sophisticated theoretical recuperation. Nonetheless, the fact that contemporary practices are linked to a hypertrophy of discourse that tries to mobilize them against the grain of their social currency is itself an indication of the

extent to which contemporary art is an integrated culture that makes use of widely available referents, involving poetic operations that are closely linked to the historical sensibility of the day. It is the inter-locking of extreme popularity and the rarefaction of criticism and theory that define this phenomenon. "Contemporary art" is, therefore, a form of aristo-cratic populism—a dialogical structure in which extreme subtlety and the utmost simplicity collide, forcing individuals of varying class, ethnic, and ideological affiliations—which might have other-wise kept them separated—to smell each other in artistic structures.

4.

The ideal of modern beauty that Stendhal articulated in 1823 as "the art of presenting to the peoples . . . works which, in view of the present-day state of their customs and beliefs, afford them the utmost possible pleasure," has finally been attained.[1] As a consequence, a temporal rift between radical aesthetics and social mores no longer exists today. The question of the death of the avant-garde ought to be reformulated to account for this institutionalization of the contemporary. As we all know, the schism between the project of modern subjectivity and the modern bourgeois subject was defined in historical terms as consisting of advances, regressions, re-enactments, futurities, and anachronism, and summarized in the politics of the avant-garde, with all the militaristic implica-tions of the term. More than the death of the avant-garde as a project of cultural subversion—always a ridiculous argument coming from the mouth of the establishment; such radicalism is sure to re-emerge in one disguise or another every time a poetic-political challenge to the *nomos* and *episteme* of

dominant society becomes necessary—the shock of the postmodern involved the realization that "the new" could no longer be considered foreign to a subjectivity constantly bombarded by media and burning with the desire for consumption.

In any case, the temporal dislocation characteristic of both modernism and the avant-garde—the way the art of the day constantly defied the notion of a synchronic present (not limited to the chronological trope of the *avant*, which encompasses any number of other historical folds, from the theme of primitivism to the negotiations with obsolescence and the ruin, the refusal of the chronology of industrial labor, and so forth)—seems to have finally found some closure. In a compelling and scary form, modern capitalist society finally has an art that aligns with the audience, with the social elites that finance it, and with the academic industry that serves as its fellow traveler. In this sense art has become literally *contemporary*, thanks to its exorcism of aesthetic alienation and the growing integration of art into culture. When, by the millions, the masses vote with their feet to attend contemporary art museums, and when a number of cultural industries grow up around the former citadel of negativity, fine art is replaced by something that already occupies an intermediary region between elite entertainment and mass culture. And its signature is precisely the frenzy of "the contemporary": the fact that art fairs, biennales, symposia, magazines, and new blockbuster shows and museums constitute evidence of art's absorption into that which is merely *present*—not better, not worse, not hopeful, but a perverted instance of *the given*.

5.

In this way, the main cultural function of art institutions and ceremonies in relation to global capitalism today is to instantiate the pandemic of contemporariness as a mythological scheme occurring (and recurring) each time we instigate this "program." After all, the art world has surpassed other, more anachronistic auratic devices (the cult of the artist, of nationality or creativity) as the profane global religion for making "the contemporary" manifest. The hunger to be part of the global art calendar has more to do with the hope of keeping up with the frenzy of time than with any actual aesthetic pursuit or interest. Mallarmé's dictum that "one must be absolutely modern" has become a duty to stay up-to-date. But given the lack of historical occasions which could represent an opportunity to experience the core of our era—pivotal revolutionary moments of significant social change or upheaval—a participation in the eternal renewal of the contemporary might not be completely misguided, for it at least invokes a longing for the specter of an enthusiasm that asks for more than just the newest technological gadget.

6.

But, once again, the devil of contemporaneousness does its deed: whereas the system of modern art was territorialized in a centrifugal structure of centers and peripheries around modernity's historical monopoly in the liberal-capitalist enclave of the North Atlantic, we now face a regime of international generalization transmitting the pandemic of the contemporary to the last recesses of the earth. In fact, the main reason for the craze surrounding the contemporary art market in recent years (and for its not having immediately collapsed

after the plunge of global capitalism) has been the market's lateral extension: bourgeoises who would previously buy work within their local art circuits became part of a new private jet set of global elites consuming the same brand of artistic products, ensuring spiraling sales and the celebration of an age in which endless "editions" allow artworks to be disseminated throughout an extended geography. In turn, each enclave of these globalized elites drives the development of a contemporary art infrastructure in their own city, using a standard mixture of global art references and local "emergent" schools. Contemporary art is defined by a new global social context in which disenfranchised wealthy individuals (who have abdicated their roles as industrial and commerce managers to the bureaucracy of CEOs) seek a certain civic identity through aesthetic "philanthropy." In this fashion they interact with a new social economy of services performed by artists, critics, and curators—services with symbolic capital that rests on an ability to trade in a semblance of "the contemporary." Contemporary art thus becomes the social structure defined by the dialectic between the new private jet set and a *jet proletariat*.

7.

This new machinery of the dialectic between the global elites of financial capitalism and the nomadic agents of global culture would be easy to dismiss as critically meaningless were it not for the way "the contemporary" also stands for the leveling of the temporal perception of cultural geography and of a certain political orientation. Particularly for those who come from the so-called periphery (the South and the former socialist world), "the contemporary" still carries a certain utopian ring. For

indeed, notwithstanding the cunning imbalances of power that prevail in the art world, the mere fact of intervening in the matrix of contemporary culture constitutes a major political and historical conquest. The global art circus of biennales, fairs, and global art museums has forced an end to the use of a metaphor that understood geography in terms of historical succession—it is no longer possible to rely upon the belatedness of the South in presuming that artistic culture goes from the center to the periphery. Although it probably does not seem so extraordinary now, the voicing of the need to represent the periphery in the global art circuits was, to a great extent, a claim to the right to participate in producing "the contemporary." And while the critical consequences of the policies of inclusion are less central to the agenda of the South than the critique of stereotypes, the activation of social memory, and the pursuit of different kinds of cultural agency, it remains the case that "contemporary art" marks the stage at which different geographies and localities are finally considered within the same network of questions and strategies. Art becomes "contemporary" in the strong sense when it refers to the progressive obsolescence of narratives that concentrated cultural innovation so completely in colonial and imperial metropolises as to finally identify modernism with what we ought to properly describe as "NATO art."

8.

This is not to say that such a process of inclusion is free from its own deformities: in many instances, a peculiar neurosis provoked by the stereotyping of ethnic, regional, or national authenticity and the pressures to accommodate art from the periphery into a subsidiary category of metropolitan

referents produces so-called "alternative modernism" or "global conceptualism." Nonetheless, the inclusion of the South in the narratives of "the contemporary" has already disrupted the genealogies of the present, such as the simplified concept of the "post-conceptual" that arose in the late 1980s to describe an apparent commonality between the radical artistic revolutions of the 1960s and the advanced art of its day. In its various historical and geographical settings, "contemporary art" claims a circularity between 1968, conceptualism, Brazilian Neo-Concretism or the French *Nouvelle Vague,* and recent works trapped in perpetual historical mirroring. In this sense, to paraphrase Walter Benjamin, "contemporary art" appears as the figure of a revolution in standstill, awaiting the moment of resolution.

Teatro Ojo, "Forget 1968 . . . but never its style." Public street interventions, October 2008, Mexico City. Photo courtesy of the author.

9.

Complicated as this may be, however, it does not blur the radical significance of the cultural transformation that took place in artistic practice in the years after 1960. One crucial element of "contemporary art" is the embrace of a certain "unified field" in the concept of art. Beyond the de-definition of specific media, skills, and disciplines, there is some radical value in the fact that "the arts" seem to have merged into a single multifarious and nomadic kind of practice that forbids any attempt at specification beyond the micro-narratives that each artist or cultural movement produces along the way. If "contemporary art" refers to the confluence of a general field of activities, actions, tactics, and interventions falling under the umbrella of a single poetic matrix and within a single temporality, it is because they occupy the ruins of the "visual arts." In this sense, "contemporary art" carries forward the lines of experimentation and revolt found in all kinds of disciplines and arts that were brought "back to order" after 1970, forced to reconstitute their tradition. "Contemporary art" then becomes the sanctuary of repressed experimentation and the questioning of subjectivity that was effectively contained in any number of arts, discourses, and social structures following the collapse of the twentieth century's revolutionary projects. I suspect that the circularity of our current cultural narratives will only be broken once we stop experiencing contemporary culture as the *déjà vu* of a revolution that never entirely took place.

10.

By the same token, it is no coincidence that the institutions, media, and cultural structures of the contemporary art world have become the last

refuge of political and intellectual radicalism. As various intellectual traditions of the left appear to be losing ground in political arenas and social discourses, and despite the way art is entwined with the social structures of capitalism, contemporary art circuits are some of the only remaining spaces in which leftist thought still circulates as public discourse. In a world where academic circuits have ossified and become increasingly isolated, and where the classical modern role of the public intellectual dwindles before the cataclysmic power of media networks and the balkanization of political opinion, it should come as no surprise that contemporary art has (momentarily) become something like the refuge of modern radicalism. If we should question the ethical significance of participating in contemporary art circuits, this sole fact ought to vindicate us. Just as the broken lineages of experimental music, cinema, and literature finally found themselves in the formless and undefined poetic space of contemporary art in general, we should not be shocked to find the cultural sector—apparently most compromised by the celebration of capitalism—functioning as the vicarious public sphere in which trends such as deconstruction, postcolonial critique, post-Marxism, social activism, and psychoanalytic theory are grounded. It would seem that, just as the art object poses a continuous mystery—a space of resistance and reflection leading towards enlightenment—so do the institutions and power structures of contemporary art also function as the critical self-consciousness of capitalist hypermodernity.

11.
However, given the negative relationship of art to its own time, one would suspect the current

radicalization of art and the constant politicization of its practice to be dangerous symptoms. Just as modern art rescued forms of practice, sensibility, and skills that were crushed by the industrial system, so does contemporary art seem to have the task of protecting cultural critique and social radicalism from the banality of the present. Unlike theorists who lament the apparent co-opting of radicalism and critique by the official sphere of art, we would need to consider the possibility that our task may consist, in large part, of protecting utopia—seen as the necessary collusion of the past with what lies ahead—from its demise at the hands of the ideology of present time. This is, to be sure, an uncomfortable inheritance. At the end of the day, it involves the memory of failure and a necessary infatuation with the powers of history. I do not know a better way to describe such a genealogy than by offering a quotation from the Dada artist and historian Hans Richter, who summarized the experience of Dada as that of "the vacuum created by the sudden arrival of freedom and the possibilities *it seemed* to offer."[2] And it may well be that contemporary art's ethical imperative is to deal with the ambivalence of the experience of emancipation. If art has indeed become the sanctuary of revolutionary thought, it is because it deals with the memory of a number of ambiguous interruptions. With this, we hopefully find an advantage to the constant collision of perfume and theory that we experience in contemporary art events around the world.

1
Stendhal, *Oeuvres complètes*, ed. Georges Eudes (Paris: Larrive, 1954), 16:27, quoted in Matei Calinescu, *Five Faces of Modernity: Modernism, Avant-garde, Decadence, Kitsch, Postmodernism*, 2nd ed. (Durham, NC: Duke University Press, 1987), 4.

2
Hans Richter, *Dada: Art and Anti-Art* (New York: Thames & Hudson, 1997), 136.

Boris Groys
Comrades of Time

1. The Present

Contemporary art deserves its name insofar as it manifests its own contemporaneity—and this is not simply a matter of being recently made or displayed. Thus, the question "What is contemporary art?" implicates the question "What is the contemporary?" How could the contemporary as such be shown?

Being contemporary can be understood as being immediately present, as being here-and-now. In this sense, art seems to be truly contemporary if it is authentic, if for instance it captures and expresses the presence of the present in a way that is radically uncorrupted by past traditions or strategies aiming at success in the future. Meanwhile, however, we are familiar with the critique of presence, especially as formulated by Jacques Derrida, who has shown—convincingly enough—that the present is originally corrupted by past and future, that there is always absence at the heart of presence, and that history, including art history, cannot be interpreted, to use Derrida's expression, as "a procession of presences."[1]

But rather than further analyze the workings of Derrida's deconstruction, I would like to take a step back, and to ask: What is it about the present—the here-and-now—that so interests us? Already Wittgenstein was highly ironical about his philosophical colleagues who from time to time suddenly turned to contemplation of the present, instead of simply minding their own business and going about their everyday lives. For Wittgenstein, the passive contemplation of the present, of the immediately given, is an unnatural occupation dictated by the metaphysical tradition, which ignores the flow of everyday life—the flow that always overflows the present without privileging it in any way. According

to Wittgenstein, the interest in the present is simply a philosophical—and maybe also artistic—*défor-mation professionnelle*, a metaphysical sickness that should be cured by philosophical critique.[2]

That is why I find the following question especially relevant for our present discussion: How does the present manifest itself in our everyday experience—before it begins to be a matter of metaphysical speculation or philosophical critique?

Now, it seems to me that the present is initially something that hinders us in our realization of everyday (or non-everyday) projects, something that prevents our smooth transition from the past to the future, something that obstructs us, makes our hopes and plans become not opportune, not up-to-date, or simply impossible to realize. Time and again, we are obliged to say: Yes, it is a good project but at the moment we have no money, no time, no energy, and so forth, to realize it. Or: This tradition is a wonderful one, but at the moment there is no interest in it and nobody wants to continue it. Or: This utopia is beautiful but, unfortunately, today no one believes in utopias, and so on. The present is a moment in time when we decide to lower our expectations of the future or to abandon some of the dear traditions of the past in order to pass through the narrow gate of the here-and-now.

Ernst Jünger famously said that modernity—the time of projects and plans, par excellence—taught us to travel with light luggage (*mit leichtem Gepäck*). In order to move further down the narrow path of the present, modernity shed all that seemed too heavy, too loaded with meaning, mimesis, traditional criteria of mastery, inherited ethical and aesthetic conventions, and so forth. Modern reductionism is a strategy for surviving the difficult journey through the present. Art, literature,

music, and philosophy have survived the twentieth century because they threw out all unnecessary baggage. At the same time, these lightened loads also reveal a kind of hidden truth that transcends their immediate effectiveness. They show that one can give up a great deal—traditions, hopes, skills, and thoughts—and still continue one's project in this reduced form. This truth also made the modernist reductions transculturally efficient—crossing a cultural border is in many ways like crossing the limit of the present.

Thus, during the period of modernity the power of the present could be detected only indirectly, through the traces of reduction left on the body of art and, more generally, on the body of culture. The present as such was mostly seen in the context of modernity as something negative, as something that should be overcome in the name of the future, something that slows down the realization of our projects, something that delays the coming of the future. One of the slogans of the Soviet era was "Time, forward!" Ilf and Petrov, two Soviet novelists of the 1920s, aptly parodied this modern feeling with the slogan "Comrades, sleep faster!" Indeed, in those times one actually would have preferred to sleep through the present—to fall asleep in the past and to wake up at the endpoint of progress, after the arrival of the radiant future.

2. Disbelief

But when we begin to question our projects, to doubt or reformulate them, the present, the contemporary, becomes important, even central for us. This is because the contemporary is actually constituted by doubt, hesitation, uncertainty, indecision—by the need for prolonged reflection, for a delay. We want to postpone our decisions and

actions in order to have more time for analysis, reflection, and consideration. And that is precisely what the contemporary is—a prolonged, even potentially infinite period of delay. Søren Kierkegaard famously asked what it would mean to be a contemporary of Christ, to which his answer was: It would mean to hesitate in accepting Christ as Savior.[3] The acceptance of Christianity necessarily leaves Christ in the past. In fact, Descartes already defined the present as a time of doubt—of doubt that is expected to eventually open a future full of clear and distinct, evident thoughts.

Now, one can argue that we are at this historical moment in precisely such a situation, because ours is a time in which we reconsider—not abandon, not reject, but analyze and reconsider—the modern projects. The most immediate reason for this reconsideration is, of course, the abandonment of the Communist project in Russia and Eastern Europe. Politically and culturally, the Communist project dominated the twentieth century. There was the Cold War, there were Communist parties in the West, dissident movements in the East, progressive revolutions, conservative revolutions, discussions about pure and engaged art—in most cases these projects, programs, and movements were interconnected by their opposition to each other. But now they can and should be reconsidered in their entirety. Thus, contemporary art can be seen as art that is involved in the reconsideration of the modern projects. One can say that we now live in a time of indecision, of delay—a boring time. Martin Heidegger has explained boredom precisely as a precondition for our ability to experience the presence of the present—to experience the world as a whole by being bored equally by all its aspects, by not being captivated by this specific goal or that one, such as

was the case in the context of the modern projects.[4]

Hesitation with regard to the modern projects mainly has to do with a growing disbelief in their promises. Classical modernity believed the future to be infinite—even after the death of God, even after the loss of faith in the immortality of the soul. The notion of a permanent art collection says it all: archive, library, and museum promised secular permanency, an infinitude that substituted the religious promise of resurrection and eternal life. During the period of modernity, the "body of work" replaced the soul as the potentially immortal part of the Self. Foucault famously called such modern sites in which time was accumulated rather than simply being lost, heterotopias.[5] Politically, we can speak about modern utopias as post-historical spaces of accumulated time, in which the finiteness of the present was seen as being potentially compensated for by the infinite time of the realized project: that of an artwork, or a political utopia. Of course, this perceived compensation obliterates time invested in the production of a certain product—when the final product is realized, the time that was used for its production disappears. However, the time lost in realizing the product was compensated for in modernity by a historical narrative that somehow restored it, using a narrative that glorified the lives of the artists, scientists, or revolutionaries that worked for the future.

But today, this promise of an infinite future holding the results of our work has lost its plausibility. Museums have become the sites of temporary exhibitions rather than spaces for permanent collections. The future is ever newly planned—the permanent change of cultural trends and fashions makes any promise of a stable future for an artwork or a political project improbable. And the past is

also permanently rewritten—names and events appear, disappear, reappear, and disappear again. The present has ceased to be a point of transition from the past to the future, becoming instead a site of the permanent rewriting of both past and future—of constant proliferations of historical narratives beyond any individual grasp or control. The only thing that we can be certain about in our present is that these historical narratives will proliferate tomorrow as they are proliferating now—and that we will react to them with the same sense of disbelief. Today, we are stuck in the present as it reproduces itself without leading to any future. We simply lose our time, without being able to invest it securely, to accumulate it, whether utopically or heterotopically. The loss of the infinite historical perspective generates the phenomenon of unproductive, wasted time. However, one can also approach this wasted time more positively, as excessive time—as time that attests to our life as pure being-in-time, beyond its value within the framework of modern economic and political projections.

3. Excess Time

Now, if we look at the current art scene, it seems to me that a certain kind of so-called time-based art best reflects this contemporary condition. It does so because it thematizes the non-productive, wasted, non-historical, excessive time—a suspended time, "stehende Zeit," to use a Heideggerian notion. It captures and demonstrates activities that take place in time, but do not lead to the creation of any definite product. Even if these activities do lead to such a product, they are presented as being separated from their result, as not completely invested in the product, absorbed by it. We find

exemplifications of excessive time, that which is not completely absorbed by the historical process.

As an example let us consider the animation by Francis Alÿs, *Song for Lupita* (1998). In this work, we find an activity with no beginning and no end, no definite result or product: a woman pouring water from one glass to another, and then back. We are confronted with a pure and repetitive ritual of wasting time—a secular ritual beyond any claim of magical power, beyond any religious tradition or cultural convention.

One is reminded here of Camus' Sisyphus, a proto-contemporary-artist whose aimless, senseless task of repeatedly rolling a boulder up a hill can be seen as a prototype for contemporary time-based art. This non-productive practice, this excess of time caught in a non-historical pattern of eternal repetition constitutes for Camus the true image of what we call "lifetime"—a period irreducible to any "meaning of life," any "life achievement," any historical relevance. The notion of repetition here becomes central. The inherent repetitiveness of contemporary time-based art distinguishes it sharply from happenings and performances of the 1960s. Now, a documented activity is not a unique, isolated performance—an individual, authentic, original event that takes place in the here-and-now. Rather, this activity is itself repetitive—even before it was documented by, let us say, a video running in a loop. Thus, the repetitive gesture designed by Alÿs functions as a programmatically impersonal one—it can be repeated by anyone, recorded, then repeated again. Here, the living human being loses its difference from its media image. The opposition between living organism and dead mechanism is obscured by the originally mechanical, repetitive, and purposeless character of the documented gesture.

Comrades of Time

Boris Groys

Francis Alÿs, *Song for Lupita*, 1998. Drawing for
animation, pencil on tracing paper, 35 x 29 cm.
Courtesy David Zwirner, New York.

Francis Alÿs has also spoken about the time of rehearsal as a similarly wasted, non-teleological time that does not lead to any result, any endpoint, any climax. An example he offers—his video *Politics of Rehearsal* (2007), which centers on a striptease rehearsal—is in some sense a rehearsal of a rehearsal, insofar as the sexual desire provoked by the striptease is itself unfulfilled. In the video, the rehearsal is accompanied by a commentary by the artist, who interprets the scenario as the model of modernity, always leaving its promise unfulfilled. For the artist, the time of modernity is the time of permanent modernization, never really achieving its goals of becoming truly modern and never satisfying the desire that it has provoked. In this sense, the process of modernization begins to be seen as wasted, excessive time that can and should be documented—precisely because it never led to any real result. In another work, Alÿs presents the labor of a shoe cleaner as an example of a kind of work that does not produce any value in the Marxist sense of the term, because the time spent cleaning shoes cannot result in any kind of final product required by Marx's theory of value.

But it is precisely because such a wasted, suspended, non-historical time cannot be accumulated and absorbed by its product that it can be repeated—impersonally and potentially infinitely. Already Nietzsche has stated that the only possibility for imagining the infinite after the death of God, after the end of transcendence, is to be found in the eternal return of the same. And Georges Bataille thematized the repetitive excess of time, the unproductive waste of time, as the only possibility of escape from the modern ideology of progress. Certainly, both Nietzsche and Bataille perceived repetition as something naturally given. But in his

book *Difference and Repetition* (1968) Gilles Deleuze speaks of literal repetition as being radically arti-ficial and, in this sense, in conflict with everything natural, living, changing, and developing, including natural law and moral law.[6] Hence, practicing literal repetition can be seen as initiating a rupture in the continuity of life by creating a non-historical excess of time through art. And this is the point at which art can indeed become truly contemporary.

4. Vita Activa

Here I would like to mobilize a different meaning of the word "contemporary." To be contem-porary does not necessarily mean to be present, to be here-and-now; it means to be "with time" rather than "in time." "Con-temporary" in German is "zeitgenössisch." As *Genosse* means "comrade," to be con-temporary—*zeitgenössisch*—can thus be understood as being a "comrade of time"—as collaborating with time, helping time when it has problems, when it has difficulties. And under the conditions of our contemporary product-oriented civilization, time does indeed have problems when it is perceived as being unproductive, wasted, meaningless. Such unproductive time is excluded from historical narratives, endangered by the prospect of complete erasure. This is precisely the moment when time-based art can help time, to collaborate, become a comrade of time—because time-based art is, in fact, art-based time.

Of course, traditional artworks (paintings, statues, and so forth) are time-based as well, because they are made with the expectation that they will have time—even a lot of time, if they are to be included in museums or in important private collections. But time-based art is not based on time as a solid foundation, as a guaranteed perspective;

rather, time-based art documents time that is in danger of being lost as a result of its unproductive character—a character of pure life, or, as Giorgio Agamben would put it, "bare life."[7] But this change in the relationship between art and time also changes the temporality of art itself. Art ceases to be present, to create the effect of presence—but it also ceases to be "in the present," understood as the uniqueness of the here-and-now. Rather, art begins to document a repetitive, indefinite, maybe even infinite present—a present that was always, already there, and can be prolonged into the indefinite future.

A work of art is traditionally understood as something that wholly embodies art, lending it an immediately visible presence. When we go to an art exhibition we generally assume that whatever is there on display—paintings, sculptures, drawings, photographs, videos, readymades, or installations—must be art. The individual artworks can of course in one way or another make reference to things that they are not, maybe to real-world objects or to certain political issues, but they are not thought to refer to art itself, because they themselves are art. However, this traditional assumption has proven to be increasingly misleading. Besides finding works of art, present-day art spaces also confront us with the documentation of art. We see pictures, drawings, photographs, videos, texts, and installations—in other words, the same forms and media in which art is commonly presented. But when it comes to art documentation, art is no longer presented through these media, but is simply stored within them. For art documentation is *per definitionem* not art. Precisely by merely referring to art, art documentation makes it quite clear that art itself is no longer available, but is absent and

hidden. Thus, it is interesting to compare traditional film and contemporary time-based art—which has its roots in film—to better understand what has happened to our life.

From its beginnings, film pretended to be able to document and represent life in a way that was inaccessible to the traditional arts. Indeed, as a medium of motion, film has frequently displayed its superiority over other media, whose greatest accomplishments are preserved in the form of immobile cultural treasures and monuments, by staging and celebrating the destruction of these monuments. This tendency also demonstrates film's adherence to the typically modern faith in the superiority of *vita activa* over *vita contemplativa.* In this respect, film manifests its complicity with the philosophies of *praxis*, of *Lebensdrang*, of *élan vital*, and of desire; it demonstrates its collusion with ideas that, in the footsteps of Marx and Nietzsche, fired the imagination of European humanity at the end of the nineteenth and the beginning of the twentieth centuries—in other words, during the very period that gave birth to film as a medium. This was the era when the hitherto prevailing attitude of passive contemplation was discredited and displaced by celebration of the potent movements of material forces. While the vita contemplativa was for a very long time perceived as an ideal form of human existence, it came to be despised and rejected throughout the period of modernity as a manifestation of the weakness of life, a lack of energy. And playing a central role in the new worship of vita activa was film. From its very inception, film has celebrated all that moves at high speeds— trains, cars, airplanes—but also all that goes beneath the surface—blades, bombs, bullets.

However, while film as such is a celebration of

movement, in comparison to traditional art forms, it paradoxically drives the audience to new extremes of physical immobility. While it is possible to move one's body with relative freedom while reading or viewing an exhibition, the viewer in a movie theater is put in the dark and glued to a seat. The moviegoer's peculiar situation in fact resembles a grandiose parody of the very vita contemplativa that film itself denounces, because cinema embodies precisely the vita contemplativa as it would appear from the perspective of its most radical critic—an uncompromising Nietzschean, let us say—namely as the product of frustrated desire, lack of personal initiative, a token of compensatory consolation and a sign of an individual's inadequacy in real life. This is the starting point of many modern critiques of film. Sergei Eisenstein, for instance, was exemplary in the way he combined aesthetic shock with political propaganda in an attempt to mobilize the viewer and liberate him from his passive, contemplative condition.

The ideology of modernity—in all of its forms —was directed against contemplation, against spectatorship, against the passivity of the masses paralyzed by the spectacle of modern life. Throughout modernity we can identify this opposition between passive consumption of mass culture and an activist opposition to it—political, aesthetic, or a mixture of the two. Progressive, modern art has constituted itself during the period of modernity in opposition to such passive consumption, whether of political propaganda or commercial kitsch. We know these activist reactions—from the different avant-gardes of the early twentieth century to Clement Greenberg (Avant-Garde and Kitsch), Adorno (Cultural Industry), or Guy Debord (Society of the Spectacle), whose themes and rhetorical

figures continue to resound throughout the current debate on our culture.[8] For Debord, the entire world has become a movie theater in which people are completely isolated from one another and from real life, and consequently condemned to an existence of utter passivity.

However, at the turn of the twenty-first century, art entered a new era—one of mass artistic production, and not only mass art consumption. To make a video and put it on display via the Internet became an easy operation, accessible to almost everyone. The practice of self-documentation has today become a mass practice and even a mass obsession. Contemporary means of communications and networks like Facebook, MySpace, You-Tube, Second Life, and Twitter give global populations the possibility to present their photos, videos, and texts in a way that cannot be distinguished from any post-Conceptual artwork, including time-based artworks. And that means that contemporary art has today become a mass-cultural practice. So the question arises: How can a contemporary artist survive this popular success of contemporary art? Or, how can the artist survive in a world in which everyone can, after all, become an artist?

One may further speak about our contemporary society as a society of the spectacle. However, we are now living not among the masses of passive spectators, as described by Guy Debord, but among the masses of artists. In order to recognize himself or herself in the contemporary context of mass production, the artist needs a spectator who can overlook the immeasurable quantity of artistic production and formulate an aesthetic judgment that would single out this particular artist from the mass of other artists. But it is obvious that such a spectator does not exist—while it could be God, we

have already been informed of the fact that God is dead. If contemporary society is, therefore, still a society of spectacle, then it seems to be a spectacle without spectators.

On the other hand, spectatorship today—vita contemplativa—has also become quite different from what it was before. Here again the subject of contemplation can no longer rely on having infinite time resources, infinite time perspectives—the expectation that was constitutive for Platonic, Christian, or Buddhist traditions of contemplation. Contemporary spectators are spectators on the move; primarily, they are travelers. Contemporary vita contemplativa coincides with permanent active circulation. The act of contemplation itself functions today as a repetitive gesture that can not and does not lead to any result—to any conclusive and well-founded aesthetic judgment, for example. Traditionally, in our culture we had two fundamentally different modes of contemplation at our disposal to give us control over the time we spent looking at images: the immobilization of the image in the exhibition space, and the immobilization of the viewer in the movie theater. Yet both modes collapse when moving images are transferred to museums or exhibition spaces. The images will continue to move—but so too will the viewer. As a rule, under the conditions of a regular exhibition visit, it is impossible to watch a video or film from beginning to end if the film or video is relatively long—especially if there are many such time-based works in the same exhibition space. And in fact such an endeavor would be misplaced. To see a film or a video in its entirety, one has to go to a cinema or to remain in front of his or her personal computer. The whole point of visiting an exhibition of time-based art is to take a look at it and then another look and

another look—but not to see it in its entirety. Here, one can say that the act of contemplation itself is put in a loop.

Time-based art as shown in exhibition spaces is a cool medium, to use the notion introduced by Marshall McLuhan.[9] According to McLuhan, hot media lead to social fragmentation: when reading a book, you are alone and in a focused state of mind. And in a conventional exhibition, you wander alone from one object to the next, equally focused—separated from the outside reality, in inner isolation. McLuhan thought that only electronic media such as television are able to overcome the isolation of the individual spectator. But this analysis of McLuhan's cannot be applied to the most important electronic medium of today—the Internet. At first sight, the Internet seems to be as cool, if not cooler, than television, because it activates users, seduc-ing, or even forcing them into active participation. However, sitting in front of the computer and using the Internet, you are alone—and extremely focused. If the Internet is participatory, it is so in the same sense that literary space is. Here and there, any-thing that enters these spaces is noticed by other participants, provoking reactions from them, which in turn provoke further reactions, and so forth. However, this active participation takes place solely within the user's imagination, leaving his or her body unmoved.

By contrast, the exhibition space that includes time-based art is cool because it makes focusing on individual exhibits unnecessary or even impossible. This is why such a space is also capable of including all sorts of hot media—text, music, individual images—thus making them cool off. Cool contemplation has no goal of producing an aesthetic judgment or choice. Cool contemplation

is simply the permanent repetition of the gesture of looking, an awareness of the lack of time necessary to make an informed judgment through comprehensive contemplation. Here, time-based art negatively demonstrates the infinity of wasted, excessive time that cannot be absorbed by the spectator. However, at the same time, it removes from vita contemplativa the modern stigma of passivity. In this sense one can say that the documentation of time-based art erases the difference between vita activa and vita contemplativa. Here again time-based art turns a scarcity of time into an excess of time—and demonstrates itself to be a collaborator, a comrade of time, its true con-temporary.

1
Jacques Derrida, *Marges de la philosophie* (Paris: Editions de Minuit, 1972), 377.

2
Ludwig Wittgenstein, *Tractatus Logico-Philosophicus*, trans. C.K. Ogden (London: Routledge, 1922), 6.45.

3
See Søren Kierkegaard, *Training in Christianity* (New York: Vintage, 2004).

4
See Martin Heidegger, "What is Metaphysics?" in *Existence and Being*, ed. W. Brock (Chicago: Henry Regnery Co, 1949), 325–349.

5
See http://foucault.info/documents/heteroTopia/foucault.heteroTopia.en.html.

6
See Gilles Deleuze, *Difference and Repetition*, trans. Paul Patton (London: Continuum, [1968] 2004).

7
See Giorgio Agamben, *Homo Sacer: Sovereign Power and Bare Life*, 1st ed. (Stanford: Stanford University Press, 1998).

8
See Guy Debord, *Society of the Spectacle* (Oakland: AKPress, 2005).

9
Marshall McLuhan, *Understanding Media: The Extensions of Man* (Cambridge, MA: The MIT Press, 1994).

Raqs Media Collective
Now and Elsewhere

The Problem and the Provocation

We would like to begin by taking a sentence from the formulation of the problem that set the ball rolling for this lecture series. In speaking of the "hesitation in developing any kind of comprehensive strategy" for understanding precisely what it is that we call contemporary art today (in the wake of the last twenty years of contemporary art activity), the introduction to the series speaks of its having "assumed a fully mature form—and yet it still somehow refuses to be historicized as such."[1]

Simultaneously an assertion and a reticence to name one's place in time, it is this equivocation that we would really like to discuss.

The Old Man and the Wind: Joris Ivens' Film

At the very beginning of Joris Ivens and Marceline Loridan's film *Une histoire de vent* (A Tale of the Wind), we see a frail Joris Ivens sitting in a chair on a sand dune in the Gobi Desert, on the border between China and Mongolia, waiting for the arrival of a sandstorm.

Elsewhere in the film, an old woman—a wind shaman—talks about waiting for the wind.

Buffeted as we are by winds that blow from so many directions with such intensity, this image of an old man in a chair waiting for a storm is a metaphor for a possible response to the question "What is contemporaneity?"

It takes stubbornness, obstinacy, to face a storm, and yet also a desire not to be blown away by it. If Paul Klee's *Angelus Novus*, celebrated in Benjamin's evocation of the angel of history, with its head caught in turning between the storm of the future and the debris of the present, were ever in need of a more recent annotation, then old man Ivens in his chair, waiting for the wind, would do very nicely.

It is tempting to think of this dual obstinacy—to face the storm and not be blown away—as an acute reticence that is at the same time a refusal to either run away from or be carried away by the strong winds of history, of time itself.

We could see this "reticence," this "refusal to historicize," as a form of escape from the tyranny of the clock and the calendar—instruments to measure time, and to measure our ability to keep time, to keep to the demands of the time allotted to us by history, our contemporaneity. Any reflection on contemporaneity cannot avoid simultaneously being a consideration of time, and of our relation to it.

On Time

Time girds the earth tight. Day after day, astride minutes and seconds, the hours ride as they must, relentlessly. In the struggle to keep pace with clocks, we are now always and everywhere in a state of jet lag, always catching up with ourselves and with others, slightly short of breath, slightly short of time.

The soft insidious panic of time ticking away in our heads is syncopated by accelerated heartbeat of our everyday lives. Circadian rhythms (times to rise and times to sleep, times for work and times for leisure, times for sunlight and times for stars) get muddled as millions of faces find themselves lit by timeless fluorescence that trades night for day. Sleep is besieged by wakefulness, hunger is fed by stimulation, and moments of dreaming and lucid alertness are eroded with the knowledge of intimate terrors and distant wars.

When possible, escape is up a hatch and down a corridor between and occasionally beyond longitudes, to places where the hours chime epiphanies. *Escape* is a resonant word in the vocab-

ulary of clockmaking. It gives us another word—
escapement.

Escapement[2]
Escapement is a horological or clockmaking
term. It denotes the mechanism in mechanical
watches and clocks that governs the regular motion
of the hands through a "catch and release" device
that both releases and restrains the levers that
move the hands for hours, minutes, and seconds.
Like the catch and release of the valves of the heart
that allow blood to flow between its chambers,
setting the basic rhythm of life, the escapement of
a watch regulates our sense
continued pulsation of our h
clocks denote our freedom f
Each heartbeat, each passing second marks the
here and now, promises the future, and recalls the
resonance of the last heartbeat. Our heart tells us
that we live in time.

The history of clockmaking saw a definite
turn when devices for understanding time shifted
away from the fluid principles of ancient Chinese
water and incense clocks—for which time was a
continuum, thus making it more difficult to surgi-
cally separate past and present, then and now—to
clocks whose ticking seconds rendered a concep-
tual barricade between each unit, its predecessor
and its follower. This is what makes *now* seem so
alien to *then*. Paradoxically, it opens out another
zone of discomfort. Different places share the same
time because of the accident of longitude. Thus
clocks in London and Lagos (with adjustments made
for daylight savings) show the same time. And yet,
the experience of "now" in London and Lagos may
not feel the same at all.

An escape from—or, one might say, a full-on

willingness to confront—this vexation might be found by taking a stance in which one is comfortable with the fact that we exist at the intersection of different latitudes and longitudes, and that being located on this grid, we are in some sense phatically in touch with other times, other places. In a syncopated sort of way, we are "contemporaneous" with other times and spaces.

My Name is Chin Chin Choo

In *Howrah Bridge*, a Hindi film-noir thriller from 1958 set in a cosmopolitan Calcutta (which, in its shadowy grandeur resembled the Shanghai of the jazz age), a young dancer, the half-Burmese, half-Baghdadi-Jewish star and vamp of vintage Hindi film, Helen, plays a Chinese bar dancer. And in the song "My Name is Chin Chin Choo," a big band jazz, kitsch orientalist, and sailor-costumed musical extravaganza, she expresses a contemporaneity that is as hard to pin down as it is to avoid being seduced by.

The lyrics weave in the Arabian Nights, Aladdin, and Sinbad; the singer invokes the bustle of Singapore and the arch trendiness of Shanghai; the music blasts a Chicago big band sound; the sailor-suited male backup dancers suddenly break into Cossack knee-bends. Times and spaces, cities and entire cultural histories—real or imagined—collide and whirl in heady counterpoint. Yesterday's dance of contemporaneity has us all caught up in its Shanghai–Calcutta–Delhi–Bombay–Singapore turbulence. We are all called Chin Chin Choo. Hello, mister, how do you do?

Contemporaneity

Contemporaneity, the sensation of being in a time together, is an ancient enigma of a feeling.

It is the tug we feel when our time pulls at us. But sometimes one has the sense of a paradoxically asynchronous contemporaneity—the strange tug of more than one time and place—as if an accumulation or thickening of our attachments to different times and spaces were manifesting itself in the form of some unique geological oddity, a richly striated cross section of a rock, sometimes sharp, sometimes blurred, marked by the passage of many epochs.

Now and Elsewhere

The problem of determining the question of contemporaneity hinges on how we orient ourselves in relation to a cluster of occasionally cascading, sometimes overlapping, partly concentric, and often conflictual temporal parameters—on how urgent, how leisurely, or even how lethargic we are prepared to be in response to a spectrum of possible answers.

Consider the experience of being continually surprised by the surface and texture of the night sky when looking through telescopes of widely differing magnifications. Thinking about "which contemporaneity" to probe is not very different from making decisions about how deep into the universe we would like to cast the line of our query.

A telescope powerful enough to aid us in discerning the shapes and extent of craters on the moon will reveal a very different image of the universe than one that unravels the rings of Saturn, or one that can bring us the light of a distant star. The universe looks different, depending on the questions we ask of the stars.

Contemporaneity, too, looks different depending on the queries we put to time. If, as Zhou Enlai famously remarked, it is still too early to tell what impact the French Revolution has had on

human history, then our sense of contemporaneity distends to embrace everything from 1789 onwards. If, on the other hand, we are more interested in sensing how things have changed since the Internet came into our lives, then even 1990 can seem a long way away. So can it seem as if it were only recently that the printing press and movable type made mechanical reproduction of words and images possible on a mass scale. One could argue that time changed once and for all when the universal regime of Greenwich Mean Time imposed a sense of an arbitrarily encoded universal time for the first time in human history, enabling everyone to calculate for themselves "when," as in how many hours ahead or behind they were in relation to everyone at every other longitude. This birthed a new time, a new sense of being together in one accounting of time. One could also argue that, after Hiroshima made it possible to imagine that humanity as we know it could auto-destruct, every successive year began to feel as long as a hundred years, or as an epoch, since it could perhaps be our last. This means that, contrary to our commonplace understanding of our "time" as being "sped up," we could actually think of our time as being caught in the long "winding down," the "long decline." It all depends, really, on what question we are asking.

And so Marcel Duchamp can still seem surprisingly contemporary, and Net art oddly dated. The moon landing, whose fortieth anniversary we have recently seen, brought a future of space travel hurtlingly close to the realities of 1969. Today, the excitement surrounding men on the moon has already acquired the patina of nostalgia, and the future it held out as a promise seems oddly dated. Then again, this could change suddenly if China and India were to embark in earnest on a second-wave

Cold War space race to the moon. Our realities advance into and recede from contemporaneity like the tides, throwing strange flotsam and jetsam onto the shore to be found by beachcombers with a fetish for signs from different times. The question then becomes not one of "periodizing" contemporaneity, or of erecting a neat white picket fence around it; rather, it becomes one of finding shortcuts, trapdoors, antechambers, and secret passages between now and elsewhere, or perhaps elsewhen. Time folds, and it doesn't fold neatly—our sense of "when" we are is a function of which fold we are sliding into, or climbing out of.

A keen awareness of contemporaneity cannot but dissolve the illusion that some things, people, places, and practices are more "now" than others. Seen this way, contemporaneity provokes a sense of the simultaneity of different modes of living and doing things without a prior commitment to any one as being necessarily more true to our times. Any attempt to design structures, whether permanent or provisional, that might express or contain contemporaneity would be incomplete if it were not (also) attentive to realities that are either not explicit or manifest or that linger as specters. An openness and generosity toward realities that may be, or seem to be, in hibernation, dormant, or still in formation, can only help such structures to be more pertinent and reflective. A contemporaneity that is not curious about how it might be surprised is not worth our time.

Tagore in China

In a strange and serendipitous echo from the past, we find Rabindranath Tagore, the Bengali poet and artist who in some sense epitomized the writing of different Asian modernities in the twentieth

century, saying something quite similar exactly eighty-five years ago in Shanghai, at the beginning of what was to prove to be a highly contested and controversial tour of China.

The poet [and here, all we need to do is to substitute "artist" for "poet"]'s mission is to attract the voice which is yet inaudible in the air; to inspire faith in a dream which is unfulfilled; to bring the earliest tidings of the unborn flower to a skeptic world.[3]

Tagore's plea operates in three distinct temporal registers: the "as yet inaudible" in the future, the "unfulfilled dream" in the past, and the fragility of the unborn flower in the skeptic world of the present. In each of these, the artist's work, for Tagore, is to safeguard and to take custody of—and responsibility for—that which is out of joint with its time, indeed with all time.

We could extend this reading to say that it is to rescue from the dead weight of tradition the things that were excluded from the canon, to make room for that to which the future may turn a deaf ear, and to protect the fragility of contemporary practice from present skepticism. Tagore's argument for a polyvocal response to the question of how to be "contemporary" was misinterpreted, in some senses willfully, by two factions of Chinese intellectuals. One faction celebrated him as an uncritical champion of tradition (which he was not), while the other campaigned against him as a conservative and "otherworldly" critic of modernity (which he refused to be). Between them, these partisans of tradition and modernity in 1920s China missed an opportunity to engage with a sense of the inhabitation of time that refused to construct arbitrary—and, indeed, uncritical—hierarchies in either direction: between past and present, east and west, then and now.

On Forgetting

As time passes and we grow more into the contemporary, the reasons for remembering other times grow, while the ability to recall them weakens. Memory straddles this paradox. We could say that the ethics of memory have something to do with the urgent negotiation between having to remember (which sometimes includes the obligation to mourn), and the requirement to move on (which sometimes includes the need to forget). Both are necessary, and each is notionally contingent on the abdication of the other, but life is not led by the easy rhythm of regularly alternating episodes of memory and forgetting, canceling each other out in a neat equation that resolves itself and attains equilibrium.

Forgetting: the true vanity of contemporaneity. Amnesia: a state of forgetfulness unaware of both itself and its own deficiency. True amnesia includes forgetting that one has forgotten all that has been forgotten. It is possible to assume that one remembers everything and still be an amnesiac. This is because aspects of the forgotten may no longer occupy even the verge of memory. They may leave no lingering aftertaste or hovering anticipation of something naggingly amiss. The amnesiac is in solitary confinement, guarded by his own clones, yet secluded especially from himself.

Typically, forms of belonging and solidarity that rely on the categorical exclusion of a notional other to cement their constitutive bonds are instances of amnesia. They are premised on the forgetting of the many contrarian striations running against the grain of the moment and its privileged solidarity. On particularly bad days, which may or may not have to do with lunar cycles, as one looks into a mirror and is unable to recognize one's own image, the hatred of the other rises like a tidal bore.

Those unfaithful patches of self are then rendered as so much negative space, like holes in a mirror. Instead of being full to the brim with traces of the other, each of them is seen as a void, a wound in the self.

This void where the self-authenticated self lies shadowed and unable to recognize itself is attributed to the contagious corrosiveness of the other. The forgetting of the emptying-out of the self by its own rage forms the ground from which amnesia assaults the world. In trying to assert who we are, we forget, most of all, who we are. And then we forget the forgetting.

Kowloon Walled City and its Memory

Nowhere, unless perhaps in dreams, can the phenomenon of the boundary be experienced in a more originary way than in cities.
—Walter Benjamin[4]

A few months ago we spent some time in Hong Kong, learning what it means to live in a city that distills its contemporaneity into a refined amnesia. We were interested in particular by what happened to the walled city of Kowloon and its memory.

Kowloon Walled City and its disappearance from the urban fabric of Hong Kong can be read as a parable of contemporary amnesia. The Walled City was once a diplomatic anomaly between China and the British Empire that functioned as a long-standing autonomous zone, a site of temporary near-permanence, an exclave within an enclave.

Kowloon Walled City is not just a border in space; it also marks a border in time—a temporary suspension of linear time by which the visitor agrees to the terms of a compact laid out by the current shape of the territory, a walled compound where a

Kowloon Walled City, Hong Kong, seen from the air in the 1970s.

delicate game between memory and amnesia can be played out, apparently till eternity. This is the frontier where reality begins to cross over into an image.

Visiting the "Memorial Park" that stands on the former site of the Kowloon Walled City today is an uncanny experience. As with all "theme parks," walking in this enclosure is like walking in a picture postcard spread over hectares rather than inches. The constructed, spacious serenity of the park, its careful gestures to the tumult of the walled city by means of models, oral-history capsules, artifacts, replicas, and remains intend to provoke in the visitor some of the frisson in the fact that he or she is standing at what was once both condemned as an urban dystopia of crime, vice, and insanitation, and hailed as an anarchist utopia. The neighborhood itself may have disappeared, but its footprint in popular culture can be discerned in the simulacral sites of action sequences in cyberpunk science fiction, gangster and horror films, manga, and multi-user computer games.

The walled city had approximately thirty thousand people living in one-hundredth of a square mile, which amounts roughly to an average population-per-unit-area density ratio of 3.3 million people to a square mile. This makes it the densest inhabited unit of space in world history.

If we think of this space as a repository of memories, it would be the most haunted place on earth.

Why do such spaces—sometimes crowded, sometimes empty (but apparently crowded with ghosts)—appear in a manner that is almost viral, such that the trope of empty but haunted streets, set in the near future of global cities, begins to show the first signs of a cinematic epidemic of our times?

Will we remember the cinema of the early twenty-first century as the first intimation of the global collapse of urban space under its own weight?

Or is this imaginary appearance of a haunting, suicidal metropolis more of an inoculation than a symptom, an early shoring-up of the defenses of citizens against their own obsolescence? How can we remember, or even represent, an inoculation that could be an obituary just as much as it could be a premonition or a warning?

The surrealist poet Louis Aragon, speaking of the disappearing neighborhoods of Paris as the city morphed into twentieth-century modernity, once wrote that

it is only today, when the pickaxe menaces them, that they have at last become the true sanctuaries of the cult of the ephemeral ... Places that were incomprehensible yesterday, and that tomorrow will never know.[5]

What happens when someone from within these spaces that were "incomprehensible yesterday and that tomorrow will never know" decides to make themselves known? How does their account of the space square with its more legendary reportage?

I recall the Walled City as one big playground, especially the rooftops, where me and my friends would run and jump from one building to the next, developing strong calf muscles, a high tolerance of pain, and control of our fear, and our feet. The rooftops were our domain, shared only with the jets that passed overhead almost within reach of our outstretched arms as they roared down the final approach to Kai Tak Airport. Among the

tangle of TV antennae we hid our kid-valuable
things, toys and things we didn't want our parents
to know about because, well, most of them were
stolen or bought with money we earned putting
together stuff in the little one-room "factories"
that were all over the Walled City—if our parents
knew we had money, they'd have taken it. We were
good at hiding things, and ourselves.
—Chiu Kin Fung[6]

Disappearance and Representation:
Haunting the Record

What does disappearance do to the telling of
that which has disappeared? How do we speak to,
of, and for the presence of absences in our lives, our
cities?

Ackbar Abbas, in his book *Hong Kong: Culture
and the Politics of Disappearance*, meditates at
length on disappearance, cities, and images:

A space of disappearance challenges historical
representation in a special way, in that it is dif-
ficult to describe precisely because it can adapt
so easily to any description. It is a space that
engenders images so quickly that it becomes
nondescript . . . we can think about a nondescript
space as that strange thing: an ordinary, everyday
space that has somehow lost its usual system
of interconnectedness, a deregulated space.
Such a space defeats description not because
it is illegible and none of the categories fit, but
because it is hyperlegible and all the categories
seem to fit, whether they are the categories of
social sciences, cultural criticism, or of fiction.
Any description then that tries to capture the
features of the city will have to be, to some extent
at least, stretched between fact and fiction . . .

If this is the case, then there can be no single-minded pursuit of the signs that finishes with a systematic reading of the city, only a compendium of *indices of disappearance* (like the nondescript) that takes into account the city's errancy and that addresses the city through its heterogeneity and parapraxis.[7]

A parapraxis is a kind of Freudian slip, an involuntary disclosure of something that would ordinarily be repressed. It could be a joke, an anomaly, a revealing slip-up, a haunting.

What does it mean to "haunt the record"? When does a presence or a trace become so deeply etched into a surface that it merits a claim to durability simply for being so difficult to repress, resolve, deal with, and put away? The endurance of multiple claims to land and other scarce material resources often rests on the apparent impossibility of arranging a palimpsest of signatures and other inscriptions rendered illegible by accumulation over a long time, and across many generations. In a sense, this is why the contingent and temporary character of the Kowloon Walled City endured for as long as it did. There is of course the delicate irony of the fact that the protection offered by its juridical anomaly with regard to sovereignty—a constitutional Freudian slip with consequences—was erased the moment Hong Kong reverted to China. The autonomy of being a wedge of China in the middle of Hong Kong became moot the moment Hong Kong was restored to Chinese sovereignty. Resolving the question of Hong Kong's status automatically resolved all doubts and ambivalences with regard to claims over the custody and inhabitation of Kowloon Walled City.

A Chinese Sense of Time: Neither Permanence nor Impermanence

It is appropriate to end with a quotation from a Chinese text from the fourth century of the Common Era, a Madhyamika Mahayana Buddhist text, *The Treatise of Seng Zhao*.

When the Sutras say that things pass, they say so with a measure of reservation, for they wish to contradict people's belief in permanence.

(And here we would gesture in the direction of the assumption that this contemporaneity is destined to be permanent; after all, this too shall pass).

And when the sutras say that things are lost, they say so with a mental reservation in order to express disapproval of what people understand by "passing."

(And here we would gesture in the direction of the assumption that this contemporaneity is destined to oblivion; after all, something from this too shall remain).

Their wording may be contradictory, but not their aim. It follows that with the sages: permanence has not the meaning of the staying behind, while the wheel of time, or Karma, moves on. Impermanence has not the meaning of outpassing the wheel. People who seek in vain ancient events in our time conclude that things are impermanent. We, who seek in vain present events in ancient times, see that things are permanent. Therefore, Buddha, Liberation, He, it, appears at the proper moment, but has no fixed place in time.[8]

What more can we say of contemporaneity? It appears at the proper moment, but has no fixed place in time. In that spirit, let us not arrogate solely to ourselves the pleasures and the perils of all that is to be gained and lost in living and working, as we do, in these interesting times.

1
Julieta Aranda, Brian Kuan Wood, Anton Vidokle, "What Is Contemporary Art? Issue One" *e-flux journal*, no. 11 (December 2009).

2
See Raqs Media Collective, "Escapement," an installation at Frith Street Gallery, London, July 8, 2009–September 30, 2009.

3
Rabindranath Tagore, "First Talk at Shanghai," in *Talks in China* (Calcutta: Visva-Bharati, 1925), quoted in Sisir Kumar Das, "The Controversial Guest: Tagore in China" in *Across the Himalayan Gap: An Indian Quest for Understanding China*, ed. Tan Chung (Delhi: Indira Gandhi National Centre for the Arts, 1998).

4
Walter Benjamin, *The Arcades Project*, trans. Howard Eiland and Kevin McLaughlin (Cambridge, MA: The Belknap Press of Harvard University Press, 1999), 88.

5
Louis Aragon, *Paris Peasant* in *Art in Theory, 1900–1990: An Anthology of Changing Ideas*, ed. Charles Harrison and Paul Wood, (Oxford, UK: Blackwell, 1993), 456.

6
Chiu Kin Fung, "Children of the Walled City," *Asia Literary Review* 10 (Winter 2008), 72–73.

7
M. Ackbar Abbas, *Hong Kong: Culture and the Politics of Disappearance* (Minneapolis: University of Minnesota Press, 1997), 73–74.

8
Chao Lun: The Treatise of Seng-chao, trans. Walter Liebenthal (Hong Kong: Hong Kong University Press, 1968).

Hans Ulrich Obrist
Manifestos for the Future

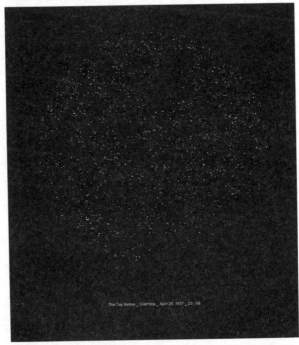

Renaud Auguste-Dormeuil, *The Day Before_Star System_Guernica_April 25, 1937_23:59,* 2004. Inkjet print mounted on aluminum and framed, 170 x 150 cm. Courtesy in situ fabienne leclerc, Paris.

Of whom and of what are we contemporaries?
What does it mean to be contemporary?
—Giorgio Agamben[1]

According to common-sense understanding, defining what we mean by the "contemporary" in art presents few problems: anything being produced in the present is always contemporary, and by the same token all art must necessarily have been contemporary at the time of its production and/or initial reception. This much is clear. It is also clear, however, that the phrase "contemporary art" has special currency today, as a commonplace of the media and of society in general. If "contemporary art" has largely replaced "modern art" in the public consciousness, then it is no doubt due in part to the term's apparent simplicity, its self-evidence. Trouble-free outside the art world, the "contemporary" is twice as useful on the inside. For one, it appears to be a purely temporal marker, simply denoting the "now," purged of critical or ideological presupposition. It appears not to require any lengthy unraveling, of the kind that Baudelaire, for example, felt to be required of the "modern," whose sense of "the ephemeral, the contingent" linked an orientation towards the future to a break with traditional values, and in particular to a break with a cyclical conception of time.[2]

In his discussion of the word "revolution," Göran Therborn has recently provided us with a striking indication of how this very shift from a cyclical conception of time to one of linearity and teleology took place in European thought:

Take the word "revolution," for example. As a pre-modern concept it pointed backwards, "rolling back," or to recurrent cyclical motions, as in

Copernicus's *On the Revolutions of the Heavenly Spheres*, or in the French Enlightenment *Encyclopédie*, in which the main entry refers to clocks and clock-making. Only after 1789 did "revolution" become a door to the future . . .[3]

Ever since the *querelle des Anciens et des Modernes* at the end of the seventeenth century, the modern has been placed in explicit opposition to some other force, whether temporal or ideological. From the start, the modern was advocated, defended, set forth as a position among others. The contemporary, on the other hand, presents itself as something of a default category or a catch-all. Yet its success may not be altogether accidental; and if it is, it may nonetheless be entirely appropriate, if for somewhat more complex reasons. It may be precisely as a catch-all that it befits today's field of artistic production more than ever, where—perhaps as a consequence of our collective disorientation—we have come to suspect modernity to be our antiquity; where the "Age of Manifestos" has long become the subject of our nostalgia—or not? Could there be a future for manifestos?

A "contemporary" manifesto could perhaps be perceived as a naïvely optimistic call for collective action, as we live in a time that is more atomized and has far fewer cohesive artistic movements. And yet there seems to be an urgent desire for a radical change that may allow us to propose a new situation, to name the beginning of the next possibility rather than just look backwards. In October 2008 this question was addressed in depth at "Manifesto Marathon," a two-day "futurological congress" we organized in the Serpentine Gallery Pavilion in Kensington Garden, London.[4]

With regard to the manifesto—and its current

absence—as a piece of printed matter, Zak Kyes (who designed the book for Manifesto Marathon) on this occasion said:

> The printed form of manifestos has always been inseparable from their radical agendas, which engage the act of publication and dissemination as sites for debate and exchange rather than mere documentation. For this reason, it is prescient to revisit the clarity and articulation—or, in many cases, willful obfuscation—of published manifestos today, a time which is defined by a panoply of publications as voluminous as they are homogenous ... For one thing is certain: without some kind of a manifesto, we cannot write alternatives that are more than vague utopias; without a manifesto, we cannot conceive the future.[5]

In his book *Utopistics*, looking at historical choices of the twenty-first century, the American sociologist Immanuel Wallerstein explored what could possibly be better—not perfect, but better—societies within the constraints of reality.[6] As a mode of deployment, the manifesto requires an opposition for it to create such a rupture. We travel through dreams that were betrayed to a world system far surpassing the limits of the nineteenth-century paradigm of liberal capitalism.

After all, the manifesto is a fundamentally transdisciplinary device, a history that is addressed in Martin Puchner's recent publication, *Poetry of the Revolution: Marx, Manifestos, and the Avant-Gardes*.[7] He breaks the history of manifestos down into three phases: first, the emergence of the manifesto as a recognizable political genre in the mid-nineteenth century (*The Communist Manifesto*, 1848); second, the creation of avant-garde

movements through the explosion of art manifestos in the early twentieth century (*Manifesto of Futurism*, 1909); and third, the rivalry between the socialist manifesto and the avant-garde manifesto from the 1910s to the late 1960s. Fifty years later, it could be said that this rivalry has faded, along with the political opposition that fueled it. In the beginning, the art manifesto did not merely register art's political ambitions; it changed the very nature of the artwork itself. "The result is . . . an art forged in the image of the manifesto: aggressive rather than introverted; screaming rather than reticent; collective rather than individual."[8] This has traditionally been the case for manifestos in the arts; however, it could be said that the twenty-first century art manifesto appears to be more introverted than aggressive, more reticent than screaming, and more individual than collective.

The striking commonality between artistic and political manifestos is their intention to trigger a collective rupture, and—like almost all manifestos in the past, which took the form of a group statement—assume the voice of some collective "we." At the "Manifesto Marathon" event the Marxist historian Eric Hobsbawm observed this to be the case with all political manifestos he could think of: "They always speak in the plural and aim to win supporters (also in the plural)."[9] Genuine groups of people, sometimes rallying around a person or a periodical, however short-lived, are conscious of what they are against and what they think they have in common—a history, Hobsbawm acknowledges, embedded in the last century. What now? Hobsbawm continued:

Of course, the trouble about any writings about the future: it is unknowable. We know what we

don't like about the present and why, which is why all manifestos are best at denunciation. As for the future, we only have the certainty that what we do will have unintended consequences.[10]

Echoing Hobsbawm, Tino Sehgal suggested a receptiveness to such unintended consequences to be a characteristic of the twenty-first century:

> I thought the twenty-first century would be, hopefully, more like a dialogue, more like conversation, and maybe that in itself is a kind of manifestation or whatever. I am very careful in even using that word. I just think the twentieth century was so sure of itself, and I hope that the twenty-first century will be less sure. And part of that is to listen to what other people say and to enter into a dialogue, to not stand up and immediately declare one's intent.[11]

But as Tom McCarthy pointed out on the same occasion, the certainty of the manifesto still lends it a certain charm:

> What interests me about the manifesto is that it's a defunct format. It belongs to the early twentieth century and its atmosphere of political and aesthetic upheaval. The bombast and aggression, the half-apocalyptic, half-utopian thrust, the earnestness—all the manifesto's rhetorical devices seem anachronistic now. For that very reason it's compelling, in the way a broken bicycle wheel was for Duchamp. Things that don't work have great potential.[12]

And yet, it is the "unbuilt" or unfulfilled nature of the future that drives manifestos, and we can perhaps

find some semblance of their utopian thrust and social imagination in projects that were for one reason or another unrealized. For every planned project that is carried out, hundreds of other proposals by artists, architects, designers, scientists, and other practitioners around the world stay unrealized and invisible to the public. Unlike unrealized architectural models and projects submitted for competitions, which are frequently published and discussed, public endeavors in the visual arts that are planned but not carried out ordinarily remain unnoticed or little known.

I see unrealized projects as the most important unreported stories in the art world. As Henri Bergson showed, actual realization is only one possibility surrounded by many others that merit close attention.[13] There are many amazing unrealized projects out there, forgotten projects, misunderstood projects, lost projects, desk-drawer projects, realizable projects, poetic-utopian dream constructs, unrealizable projects, partially realized projects, censored projects, and so on. It seems urgent to remember certain roads not taken, and—in an active and dynamic, rather than nostalgic or melancholic way—transform some of them into propositions or possibilities for the future.

And here one encounters a paradox in the contemporary, just as the historicizing of modernism has itself been paradoxical: how can the ephemeral, the contingent, and the future be things of the past? For within the art world nowadays, the term "contemporary" does indeed most often assume a periodizing function, and such temporal markers always imply a before and an after. It is in this way that the "contemporary" presupposes more than it initially declares, and begins to approach a more specialized usage, one that may require

nothing more than its repeated use within the ranks of the art world for its meaning to be apparent. But, with this repeated use, "contemporary art" loses its semblance of simplicity and begins to demand its own "before." Of course, attempts to pinpoint a decisive historical break between the modernist and the contemporary are mostly stillborn and will lead to nothing but interminable wrangling. To give just one example, "the turn of the 1960s" will never do, just as the central claim of Fred Kaplan's fascinating recent account of the year 1959—"the year everything changed," as he puts it—should likewise be taken with a pinch of salt.[14]

What is it that makes the "contemporary" maybe worth rescuing from the charges I have outlined—of equivocation, default legitimacy, or just plain bad common sense? It may be what is perhaps most clearly seen in its use as a noun: the word "contemporary" implies a relation; one is a contemporary of another. The word "contemporary" is traceable to the Medieval Latin word, "contemporarius," whose constituent parts "con" ("with") and "temporarius" ("of time") similarly point towards a relational meaning: "with/in time." What is suggested here then, and what Baudelaire's "modern" seems to disregard, is a plurality of temporalities across space, a plurality of experiences and pathways through modernity that continues to this day, and on a truly global scale.

The French historian Fernand Braudel describes how in the *longue durée* (long duration) there can be seismic shifts, like that which occurred in the sixteenth century as the center of power shifted from the Mediterranean to the Atlantic.[15] We are now living through a period in which the center of gravity is transferring to new worlds. The second half of the twentieth century was very much a time

of the "Westkunst," to use the title of Kasper König and Laszlo Glozer's groundbreaking exhibition.[16] The early twenty-first century is witnessing the emergence of a multiplicity of new centers, above all in Beijing, Shanghai, Guangzhou, Shenzhen, Hong Kong, Seoul, Tokyo, Mumbai, Delhi, Beirut, Tehran, and Cairo, to give a few examples. Since the 1990s, exhibitions have contributed considerably to this new cartography of art.

One great potential of the exhibition is to be a catalyst for different layers of input in the city. The multiplication of these events can be seen positively in terms of the multiplication of centers. The quest for the absolute center that dominated most of the twentieth century has opened up to include a plurality of centers in the twenty-first, and biennales are making an important contribution to this. They can also form a bridge between the local and the global. By definition, a bridge has two ends, and as the artist Huang Yong Ping recently pointed out: "Normally we think a person should have only one standpoint, but when you become a bridge you have to have two."[17] This bridge is always dangerous, but for Huang Yong Ping the notion of the bridge creates the possibility of opening up something new. The "contemporary" is thus spatiotemporal through and through.

In January–December 1993 as part of Museum in Progress, Alighiero e Boetti made a variation of his work *Cieli ad alta quota* in which six versions of the watercolor drawings were published in Austrian Airlines' in-flight magazine *Sky Lines*.[18] In addition, airline passengers could ask stewards for the same works in the form of jigsaw puzzles, which were the same size as the folding tables in the airplane. The six details of *Cieli ad alta quota*, which showed a certain number of airplanes flying

within in a specific area in various directions, always implies the potential for expansion; continuing beyond the frame at both high and low altitudes. Destinations connect and interweave to form networks of lines along which meaning is created though the variety of possibilities for the migration of forms.

The impossibility of capturing form in Boetti's *Cieli ad alta quota* takes us to Giorgio Agamben's "What Is the Contemporary?" which shows the one who belongs to his or her own time to be the one who does not coincide perfectly with it—to capture one's moment is to be able to perceive in the darkness of the present this light which tries to join us and cannot: "the contemporary is the person who perceives the darkness of his time as something that concerns him, as something that never ceases to engage him."[19]

Defining contemporaneity as precisely "that relationship with time that adheres to it through a disjunction and an anachronism," he goes on to describe this contemporary figure as the one who is not blinded by the lights of his or her time or century: "The contemporary is he who firmly holds his gaze on his own time so as to perceive not its light, but rather its darkness."[20] Agamben takes us to astrophysics to explain the darkness in the sky to be the light that travels to us at full speed, but which cannot reach us, as the galaxies from which it originates recede faster than the speed of light. To discern the potentialities that constantly escape the definition of the present is to understand the contemporary moment.

Jean Rouch often told me about the immense courage required in order to be contemporary, to engage in the difficult negotiation between the past and the future. Like Agamben, he spoke of a means

of accessing the present moment through some form of archaeology. Both Rouch and Agamben agree that being contemporary means to return to a present we have never been to, to resist the homogenization of time through ruptures and discontinuities. Agamben concludes:

> This means that the contemporary is not only the one who, perceiving the darkness of the present, grasps a light that can never reach its destiny; he is also the one who, dividing and interpolating time, is capable of transforming it and putting it in relation with other times. He is able to read history in unforeseen ways, to "cite it" according to a necessity that does not arise in any way from his will, but from an exigency to which he cannot not respond. It is as if this invisible light that is the darkness of the present cast its shadow on the past, so that the past, touched by this shadow, acquired the ability to respond to the darkness of the now.[21]

1
Giorgio Agamben, "What Is the Contemporary?" in *What Is an Apparatus? and Other Essays*, trans. David Kishik and Stefan Pedatella (Stanford, CA: Stanford University Press, 2009), 53.

2
Charles Baudelaire, "The Painter of Modern Life," in *The Painter of Modern Life and Other Essays*, 2nd ed., trans. and ed. Johnathan Mayne (London: Phaidon Press, 1995), 13.

3
Göran Therborn, *From Marxism to Post-Marxism?* (London: Verso, 2008), 129.

4
Taking place on October 18 and 19, 2008, "Manifesto Marathon: Manifestos for the 21st Century" was the third in the Serpentine Gallery's series of marathon events, and addressed the question of how to develop manifestos at a time when fewer artists work in formal groups and there are significantly fewer artistic movements than in the past century. Hans Ulrich Obrist invented the interview marathon concept in Stuttgart in 2005 as an experimental kind of public event that bridges panel discussion, exhibition, and performance. In 2006 the concept evolved as Rem Koolhaas joined Obrist in interviewing over seventy people in a twenty-four hour marathon that took place in the Serpentine Gallery's summer pavilion, co-designed by Koolhaas and structural designer Cecil Balmond. The pavilion was one of an ongoing series of annual architecture commissions conceived by Serpentine director

Julia Peyton-Jones. The 2006 marathon was followed by the Experiment Marathon with Olafur Eliasson in 2007, the 2008 Manifesto Marathon, and, last but not least, the Poetry Marathon in 2009. In December 2009 Obrist and Koolhaas engaged the rapidly growing city of Shenzhen with "Shenzhen Marathon: The Chinese Thinking."

5
Zak Kyes at "Manifesto Marathon," October 18, 2008.

6
Immanuel Wallerstein, *Utopistics: Or, Historical Choices of the Twenty-First Century* (New York: The New Press, 1998).

7
Martin Puchner, *Poetry of the Revolution: Marx, Manifestos, and the Avant-Gardes* (Princeton University Press, 2006).

8
Ibid., 6.

9
Eric Hobsbawm, at "Manifesto Marathon," October 19, 2008.

10
Ibid.

11
Tino Sehgal, at "Manifesto Marathon," October 19, 2008.

12
Tom McCarthy, at "Manifesto Marathon," October 18, 2008.

13
See Henri Bergson, *Creative Evolution* (New York: Dover, 1998 [1911]).

14
See Fred Kaplan, *1959: The Year Everything Changed* (Hoboken, NJ: Wiley, 2009).

15
See Fernand Braudel, *The Mediterranean and the Mediterranean World in the Age of Philip II*, vol. 2, trans. Siân Reynolds (Berkeley: University of California Press, 1995).

16
"Westkunst," Museen der Stadt Köln, Cologne, West Germany, May 30–August 16, 1981.

17
Huang Yong Ping in conversation with Rohini Malik and Gavin Jantjes, trans. Hou Hanru, Fondation Cartier, Paris, March 8, 1997.

18
The Exhibition "Cieli ad alta quota" was curated by Hans Ulrich Obrist for Museum in Progress and Austrian Airlines.

19
Agamben, "What Is the Contemporary?," 45.

20
Ibid., 41, 44.

21
Ibid., 53.

Hu Fang
New Species of Spaces

What Is Contemporary Art?

Bo wu zhi (History of Nature), compiled by Zhang Hua during the Western Jìn Dynasty (265–316), is the first study of natural history in China. In this ten-volume book, Zhang recorded geographic features of the landscape, animals, biographies, myths and ancient history, immortals and ancient alchemy, and so on. He placed all that could not be categorized into a special section entitled "The Miscellaneous."

 If we take the whole world to be a book, then we are today lost in its multiple narratives and countless miscellanea. If we take it as a medium through which to reflect and explore the world, this book is no longer able to keep up with the speed at which narratives now unfold in it.

> As a central building in the community, cinema is the largest luminous architectural body. Lights and film are cast in the sky of community, and linked with lights of city, of course, cast on bodies and faces from the bottom-up, as like the final scene in Genesis. A bustling city appears before us, and accomplishments under foot, there is an impassable and high aloft feel ...
> — Beijing-based real estate ad magazine *Contemporary MOMA*, No.8

The Linked Hybrid building, also known as 当代 MOMA (Contemporary MOMA) is a residential building complex designed by American architect Steven Holl for Beijing. This huge residential container is more like an epochal allegory of the imaged space of reality. It proclaims:

1. Reality will become a set in a film.
2. Residents will be the stars of the film.
3. The architect will become the film's director.

Hu Fang

New Species of Spaces

In this way, architects and developers encourage people to participate in the creative process of "seeing" and "being seen" in the performance of contemporary life.

If seeing is an act of consciousness, then today such an activity seems to create its own reality: the mirror. Through his works, Dan Graham revealed the significant psychological effects of the semi-reflective glass used in shopping centers and office buildings on people, particularly at moments when one's own reflected image fuses with that of the goods displayed behind the glass. This fusion produces an entirely new self-image. While of course Graham shows that this new self-image is of someone who wants to purchase the goods behind the window, he also touches upon the most fundamental cultural condition of urban life, namely that urban living space has become a continuous system of self-reflection in which "I" can never perceive the existence of other people beyond my own mirrored image, just as the city itself cannot perceive any other parts of the world, but only its own reflection.

People experience an endless carnival within a cycle of their own mirrored images, and the city lives within its own mirrors endlessly. This is the beginning of exhausted self-experience.

Do we still have a real relationship with reality?

He withdraws his eyes from the flashing computer screen back to the gray horizon beyond the glass wall, where thick clouds are lit by a gloomy sunset, where high-rises extend one after another into the endless distance like reproducing cells, together creating our living borders through rapid replication and continuous hybrids.

New Species of Spaces

Hu Fang

In einem Ballsaal 15 Meter unter Wasser sollen die Gäste Walzer tanzen und durch eine gläserne Kuppel, die aus dem Meer ragt, in den Stern himmel schauen – so plant ein deutscher Unternehmer das Hotel Hydropolis // In a ballroom 15 meters down, guests at the Hydropolis Hotel be able to dance or gaze at the stars through a glass dome that extends out of the water – at least that's what one German businessman is pla

H₂Otel

lionen Menschen tauchen jedes Jahr ins Meer. Nun sollen sie dort auch wohnen. In den nächsten Jahren
stehen in Poseidons Reich Luxushotels und Spielcasinos. In Florida ist eine Nacht in der Tiefe bereits möglich

ery year, millions of people explore Poseidon's realm in a diving suit. Soon, luxury hotels and casinos will start
inging up underwater, too, and in Florida, you can already spend a night beneath the waves

Pressing the keyboard, a theme park weaves, accumulates, rotates, and diffuses in color.

In a city of constant destruction and reconstruction, history has been superimposed constantly, and to a point where it is so blurred that it can no longer be seen.[1]

In a novel I wrote entitled *Garden of Mirrored Flowers*, I began to imagine the figure of an architect who gradually found the maze of life revealing itself to him as he constructed a theme park called "Garden of Mirrored Flowers."

In contrast to Borges' "The Garden of Forking Paths," the maze of life in *Garden of Mirrored Flowers* could perhaps be a direct contact with reality itself, with the novel serving as a "documentary" of it—a collection of those traces in reality, such as television advertisements, stock market summaries, cell phone messages, shopping lists, and so on, which are always shown as dramatic events. From political performances to economic crises, the production of reality in the form of a story seems to occur in abundance today.

Thus, this novel becomes a "script" of reality, as the Russian writer Victor Pelevin suggests with regard to the Russian literary tradition in the preface to the Chinese edition of *Generation* "П," "In Russia, the writers do not write novels, but scripts."

In this case, "I" am not the author of the novel, but rather, reality writes its own novel by my hand. This reality then grows increasingly surrealistic and begins to overflow, becoming saturated to a point where it is emptied of its own value.

If we agree that our reality becomes increasingly like the thoughts secreted by an insane collective mind, then can we even see this reality?

Spaces have multiplied, been broken up and have diversified . . . To live is to pass from one space to another, while doing your very best not to bump yourself.
—Georges Perec[2]

In the misty mist, you pass through a jungle or a mountain. At one point, the road forks: to the left is the first life; to the right, the second life.

Without Cao Fei / China Tracy's *I.mirror*, I would not have encountered a life called Second Life, where there appear to be new concepts of life and death, new histories and new worldviews. But soon we will find Second Life to be not an entirely new world, but rather the same life as the first one. *I.mirror* shows the beautiful landscape at the end of the world's wilderness; it is not about the future, but is a metaphor for daily life and the politics of the present.[3]

In other words, the aesthetics of the future are not mysterious.

They exist along a blurry border between reality and fantasy, and will disappear over the horizon just as life will. But artists will be more engaged in life—no longer as a solidified reality with an original single meaning, but as a continuous flowing process.

I observe in the artistic works of the individuals around me—Cao Fei, Ming Wong, Xu Tan, Pak Sheung Chuen, Yang Fudong, Zheng Guogu—the recognition of a complex relationship between art and reality: art no longer operates in a laboratory of artists, but as intuitive and active participation in the possibility of life. In this sense, I think our question for art shall concern what it can "become," but not what it "is," and we can say that, from the beginning, the purpose of such creation will not be

to produce something that becomes a work, but that acts as a force to be integrated in many different contexts. Such creativity shall and will continuously raise questions with regard to social life and stimulate our consciousness of life in general, as well as our actions.

These individuals regard life itself as a process of experimentation and develop their own unique ways of perceiving the world. As opposed to an unconscious involvement, these figures always have the ability to "intend" movement in a certain direction, which is to say that they are always likely to construct a dynamic relationship *between* and *around*, to generate an integration of multiple relationships through their art practices, making the work itself a kind of *Post-fact*: both the result of a transformation and a proposal, which will in turn touch, and deeply influence the relevant groups, and reality itself. Based on such a premise—that is, if we regard the practice of art as a reconstruction of a relationship to life (such a relationship is no longer a definite social determination, but a fundamental and philosophical understanding)—it must be bound to the direction of its spaces and groups, and become a proposal for constructing the possibility of life.

These different forms of creativity with different orientations respectively become different spaces, but they also suggest the existence of a truly diverse, new species of space—one that will inspire a new space for life.

1
Hu Fang, *Garden of Mirrored Flowers* (Guangzhou, China: Vitamin Creative Space, 2009)

2
Georges Perec, *Species of Spaces and Other Pieces*, ed. and trans. John Sturrock (London: Penguin Classics, 1998), 6.

3
See "China Tracy: i.Mirror," http://www.youtube.com/watch?v=5vcR7OkzHkl.

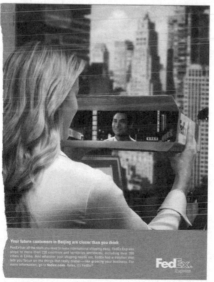

Jörg Heiser

Torture and Remedy: The End of -isms and the Beginning Hegemony of the Impure

There is a sharp contrast between, on the one hand, the often blunt commodification of art (and the processes of branding and generating wealth connected with it), and, on the other, the extremely heterogeneous, fragile practice of creating art. In fact, a good part of what makes an artist succumb to blunt commodification is the sheer anxiety caused by that heterogeneous fragility. Producing easily marketable, no-questions-asked work can offer a (deceptive) security no longer provided by classical avant-garde panache. There is no clearly distinguishable movement in sight that would lead out of this apparent deadlock. Given this, what are the options, the cracks of light in the otherwise uniformly dark, dystopian vision of poor, anxious artists doing irrelevant work for the rich? The answer to this question, as I will argue, is that today there is a kind of movement whose point is *not* to be clearly distinguishable, not to be "pure" anymore, not to allow itself to be historicized that way.

But before making that argument, it's necessary to understand what the last clearly distinguishable movements were, and why there now are none. The last period in visual arts that produced such movements was the 1960s: Pop Art, Minimal Art, and Conceptual Art. These movements were "distinguishable" because they were defined by a small set of methodological operations that could be identified as innovative in comparison to other achievements in art, whether earlier or contemporaneous. In other words, they were avant-gardes. Still, defining the "essence" and "newness" of these movements, or deciding whose work belongs clearly enough to any of them, has remained an often ideologically charged issue for many artists, critics, and scholars alike. And many of them have abandoned the very idea of a "movement." Usually they have

done so in the name of either idiosyncrasy or the genius of the individual artist. Or they have done so, on the contrary, in the name of a more totalized idea of creative collectivity that supposedly "transcends" the limits of an "-ism" or mere "style."

But whether or not you're against the idea of movements no longer seems to be the problem. From the 1970s on, it has been difficult or next to impossible to clearly identify them in the first place. Everything became "neo-this" or "post-that," or a pronounced crossbreed between previous movements. Around the early 1980s in Europe and the U.S., "neo-expressionist" painting set out to reinvigorate older ideas of artistic intensity and immediacy, but—to generalize—remained less about changing the way you painted than about changing the way you presented yourself doing so. The method—paint fast, wittily—was considered a direct outpouring of a (usually masculine) rebellious attitude. At around the same time, neo-conceptual or appropriation artists such as Richard Prince or Sherrie Levine built on the achievements of Marcel Duchamp and Andy Warhol, on the ideas of the readymade, of appropriating existing cultural artifacts as art, and of making intelligent artistic use of reproduction technologies. But regardless of their qualities as individual artists, the question remains whether they truly advanced or departed from these pioneers with that methodology. The same could be said of artists such as Rirkrit Tiravanija or Philippe Parreno who, from the mid 1990s on, have been associated with the catch phrase "Relational Aesthetics": did their artistic evocations of social situations (whether cooking in a gallery or buying the rights to a Japanese anime character), their deconstructions of the categories of "artwork" and "exhibition," really move beyond the achievements

of the 1960s? After all, already in 1969 a conceptual artist, for example, offered a reward of $1,100 for information leading to the arrest of a bank robber wanted by the FBI (Douglas Huebler, *Duration Piece No. 15, Global*). In the contemporary Chinese context, similar questions can probably be asked about the "Cynical Realism," "Political Pop," or "Gaudy Art" styles of the 1990s: besides their aspirations to subvert through satirical, ironical, or grotesque figurative representation and their indisputable pioneering importance for the establishment of a new art scene, what did they really achieve methodologically in comparison to earlier movements?

In any case, rather than evoking the sense (or illusion?) of something radically new, these post- and neo- or cross-breed-movements, for better or worse, all seemed to be about re-investigating the heritage of previous movements (if seen generously), or about devouring their corpses (if seen nihilistically). Or is that all a retroactive illusion? Were the 1960s movements, which were equally concerned with historical predecessors, maybe more clever in concealing that fact? Were the postwar movements, as theoreticians such as German literary critic Peter Bürger have argued, merely recycling the early twentieth-century avant-gardes?[1] And what does this mean for ideas of shock, radicality, and criticality? And can we still meaningfully categorize art in this way today?

Before we can explore all of these questions further, there are two points that need to be clarified. The first concerns the three aforementioned 1960s movements: we need to understand how exactly it became possible to give each a simple, singular name: Pop, Minimal, Concept. What does that tell us about their nature and continuing influence? The second point is that the seeming

disappearance of clearly distinguishable movements is not at all exclusive to visual art, as similar developments can be discerned in other realms such as music, philosophy, and politics. In other words, a more fundamental sea change seems to be at work.

Pop/Minimal/Concept

So what is it that made Pop, Minimal, and Concept such appealing one-name signifiers? And why is it that we can no longer come up with anything as succinct and to the point in "labeling" broader developments in art? There is not enough space here to develop a full history of these terms, much less discuss the full range of artists and movements associated with them. So in order to answer this question, it's worth examining the meanings of these one-name labels as such, and what those meanings might tell us about what decisive factors distinguish an artistic movement.

The term "Pop Art" was invented in Britain in the mid 1950s. It was first used in conversation between members of the Independent Group: a number of artists, architects, writers, and critics who held meetings at the Institute of Contemporary Art in London, seeking to challenge prevailing notions of modern art. The artist Eduardo Paolozzi, a Scottish-born son of Italian immigrants, at the first meeting in 1952, showed a series of collages composed mostly of found elements from American mass culture. One of them included the word "pop," placed on a cloud emerging from a revolver, followed by an exclamation mark, cut out of a comic strip and collaged onto the cover of a magazine of erotic pulp stories called "Intimate Confessions." So the word is onomatopoetic: it emulates the sound of a shot, or of a bubble bursting—pop! The sound of a sudden

release of energy, light rather than heavy. The association of this energy with light entertainment is made even clearer in the other seminal collage from the early days of Pop Art: Richard Hamilton's *Just What Is It That Makes Today's Homes So Different, So Appealing?* (1956). The collaged living room scene, similar to Paolozzi's work, ironically alludes to romance and sex in a slapstick collision of clichés of masculinity and femininity. The bodybuilder placed in the middle holds what looks like a tennis racket, but is in fact a huge lollipop inscribed with the capital letters "POP"—which also happens to be the colloquialism for "lollypop." This English term dates back to the eighteenth century, and initially referred to soft candy. It may have derived from "lolly" (tongue) and "pop" (slap).[2] The first references to the lollipop as hard candy on a stick dates to the early twentieth century, when it became possible to mass-produce them.[3] The term "soda pop," for sweet soft drinks such as Coca-Cola, also presumably stems from this period—probably earning its name from the sound one hears when opening the bottle. Either way, what we have here is a conversion between light-hearted pleasure and craving desire: the connection between innocent sweetness and bluntly sexual connotations, which the works by both Paolozzi and Hamilton do more than just allude to. In the latter's case, the lollipop, through its placement at the crotch of the muscular man, becomes a grotesquely bulbous phallus. The origins of Dada and Surrealism are here, but so is the new teenage culture of rock 'n' roll that moves and shakes and sexualizes the bodies of a much broader populace.

The art critic Lawrence Alloway is often credited with having first come up with the term "Pop Art." But he identified the movement without using

the term. In his 1958 essay "The Arts and the Mass Media," though he speaks of "mass popular art," he does not address fine arts to any great extent.[4] Rather, he argues much more broadly for the validity of popular culture itself, thus paving the way for this new art. In any case, here we have the more obvious, technical meaning of the word "pop"—as an abbreviation, simply, for popular: the culture of, and for, the many. But the onomatopoetic meaning of "pop!"—the sound of a conversion between light-hearted innocence and almost violent desire—permeates this technical meaning. This culture of and for the many is not merely defined by quantity but also by a particular quality, a kind of instantly inflating and deflating delight, like the refreshing sound of a bottle opening, or the silly "pop" of a deflating balloon, a quality for which it is praised or scorned, sometimes both at once—Pop!

The Pop artists transferred this instanta-neousness into the realm of art, turning slight delight into eternalized epiphany. But this "transfig-uration of the commonplace," to use Arthur Danto's phrase, does not turn Pop artists into priests of this transfiguration.[5] Rather, they are just exceptional, or exemplary, in singling out the occurrences of this delight-as-epiphany. This decidedly marks the shift from the first British Pop art of Paolozzi and Hamilton, still in the tradition of the Dada/Surrealist collage (as Peter Bürger had suspected), and that of Andy Warhol's substitution of collage with serializa-tion. In doing this, Warhol is not just applying one more clever idea; he erases the "artistic" exempli-fication of composition still present in collage to expose the artist as simply, or merely, an exemplary or substitutional consumer—someone who makes a picture choice. At the same time, he also erases "comment": while a collage still suggests a meaning

and an opinion, serialization—by leaving elements to collide suggestively—dissolves meaning and opinion into ambiguity. One could suspect that Warhol *celebrates* the Coca-Cola bottle or Marilyn Monroe by serializing their image in silkscreen, but does that apply to the newspaper image of an electric chair as well? In either case, the mechanistic approach is the point. The sudden inflating/deflating "pop" sound represents our passiveness in the moment we are caught unawares vis-à-vis the commodity: our opinion or choice in regard to these images (a choice often structurally preconditioned by what is made available in our society in the first place) is no more than that of a consumer, a reader, a viewer. But even if we do not really like them, we have to admit that they affect us. At this point, the artist is no longer the producer, as opposed to the viewer, but the exemplary viewer and the exemplary consumer—a particular kind of consumer: the "classical" consumer who has a relatively stable set of choices and references that are part of his social identity (I'll return below to the definition of the "consumer"). If Pop celebrates anything, it is not commodities as such, but this totalized identification of the artist with the role of the spectator/consumer confronted with commodities.

Minimal
When Minimal art first emerged in the U.S., it seemed to be the antidote to all of this. No visual icons of the commodity world, just plain surfaces, reduced geometries. The term was arguably first used by the critic Richard Wollheim in an essay entitled "Minimal Art," published in 1965.[6] But it took years for it to catch on. Other terms such as Rejective art, ABC art, Specific Objects, Reductivism, and Primary Structures were launched. Only

the last two, like "Minimal," place the emphasis on simplification. "Rejective" emphasizes the departure from any kind of comforting "illusionist space," story, or allegory in this kind of work; "ABC" its steady, simplistic seriality; and "specific object" its departure from the traditional categories of painting and sculpture.

But why did "Minimal Art" catch on? First of all, because it resonated with phenomena in other disciplines that seemed motivated by similar concerns—"minimalism" was something happening in music and dance, and arguably in film and literature, as well. What these movements share according to that view, however, is not merely an ideal of reductive form, but also a methodology of allowing things to stand or speak for themselves in an unpretentious, matter-of-fact way, that is, without the claim of a grand genius mind purveying them; without the display of handicraft; replacing lyrical or dramatic movement with serial movement; and maybe most importantly: providing a structure in which production and reception can interact. In the serial music of someone like Terry Riley, the performers often have more to do than just "interpret"; or the "actual" performing is done with a recording, while listeners have to possibly be more acutely active to immerse themselves in the space-time continuum of the music. But it's also apparent in the idea most notably put forth by the minimal artist Robert Morris that the crucial point of minimal art is to establish a spatial relation between viewer and object, heightening the viewer's self-awareness.[7] An entire discussion has centered on the value of this emphasis on the viewer-work relation as opposed to qualities supposedly intrinsic to the work itself. But that discussion of evaluation aside, there is a *structural* kernel to all these aspects of minimal art. Pop art

freeze-frames what consumers of popular culture experience into an iconic abstraction; minimal art, on the contrary, establishes simple structures that are like model scenarios for how aesthetic experience occurs in the first place. This happens almost literally in the sense of what Jacques Rancière calls the "distribution of the sensible": establishing a form or manner in which something can appear, or "lend itself to participation."[8] Pop art hypostatized the receptive realm of consumption, while minimal art hypostatized the transitory realm of distribution or circulation—the realm where relations between production and consumption, object and viewer are negotiated. To substantialize or eternalize such a relational realm seems a contradiction in terms, but it's not: what minimal artists offer in the way of viewer participation is an exemplary, simplified, model case. Its "minimal" quality is what makes its status as a model case apparent.

Concept

The term "Concept Art" was arguably first used by Henry Flynt, a writer and musician loosely associated with the Fluxus movement. In 1961 he wrote that the material of this kind of art consists of "concepts," just as sound is the material of music.[9] But it probably wasn't until around 1968 that the term "*Conceptual* art" had fully established itself. Famously, Sol LeWitt stated: "the idea is the machine that makes the art."[10]

Lawrence Weiner's 1968 "Declaration of Intent" is a good example of how this idea-as-machine is supposed to work:

1. The artist may construct the piece.
2. The piece may be fabricated.
3. The piece need not be built.

Each being equal and consistent with the intent of the artist the decision as to condition rests with the receiver upon the occasion of receivership.[11]

This sounds more mysterious than it actually is. It's like a manual, the kind of manual you get, say, to build a pre-fabricated shelf. "The piece need not be built" just means that the existence of the artwork, as an idea, is not dependent on a particular physical manifestation. The "receiver" decides whether they want to put the "thing" (even if it's not actually a thing) together or not.

Conceptual art in this sense mimics what an industrial designer or engineer might do: they design a brilliant new car, and even if the company decides not to build it, or no one wants to buy it, the design has come into existence and might have an influence on other designers and engineers. Of course this comparison is a little unfair, because the point of Conceptual art is precisely to take the *utilization* of ideas towards a sellable "product"— whether a shelf or a car—out of the equation. The idea itself is what is supposed to count.

Many conceptual artists would read the Austrian philosopher Ludwig Wittgenstein, attracted to the way he combined clearheaded analysis of language and logic with a playful, deadpan style of writing. A good example—though not by an artist whose work is "purely" conceptual—is Bruce Nauman's adaption of a phrase from Wittgenstein's *Philosophical Investigations*: he cast the sentence "A Rose has no Teeth" in lead, like a memorial plaque, and fixed it to a tree in a park (1966); later, he made copies in plastic and sent them to people in the mail. Wittgenstein had used the sentence in a comparison with the sentence "A baby has no

teeth"—the problem he was concerned with being that grammar alone can't distinguish plausible from implausible statements. Nauman's reaction complicates the matter by casting an absurd-seeming sentence in lead, as if a poetics could emerge that suddenly highlights the actual profundity of the sentence "a rose has no teeth." It's as if Nauman were saying: what seems like a faulty design—an absurd sentence—can actually be turned into something interesting. The conceptual artists, on the idea level, turned nothing into something; and on the physical level, turned something into nothing (even Nauman's lead plaque would eventually be overgrown by the tree).

The conceptual artist—whether concerned about art alone, or about the social and political sphere as well—impersonated the unashamedly absurd producer: a figure that is half-smart engineer, half-eccentric dilettante. In any case, emphasis is placed on highlighting the idea as anticipating—and prior to—any physical manifestation, the circulation and reception of a work. LeWitt's "the idea is the machine that makes the art" in this sense also marks the heyday of industrialization, the devaluation of handicraft, and the dawning of an era in which indeed ideas—or at least information—are the "means of production" rather than actual machines. This can obviously lead to all kinds of suspicions: was conceptual art merely celebrating the new capitalist culture, the fetish of information and communication technology, the desubjectivation of production and administration? I think these suspicions are beside the point as long as they generalize about the whole movement— because ultimately the problem is not that you produce but *what* you produce; not that you have an idea, but *what kind* of idea.

Production, Distribution, Consumption

But in any case, in my own admittedly schematic characterization, these three movements of the 1960s captured the basic economic triad of production, distribution, and consumption. Conceptual art is about the production of ideas that in turn produce the art; Pop art is an artistic exploration of the standards of the contemporary spectator's experience; and minimal art is about structural parameters of space, materiality, geometry, and so on, that form the conditions under which aesthetic experiences that might lead to ideas can occur. Distribution or circulation are the realms in which production is both engendered in the first place (the means of production needs to be distributed before production can take place), and negotiated and compartmentalized in regard to consumption or reception. My argument however is not that these three artistic movements were simply illustrating the three basic aspects of the socioeconomic reproduction of society. Rather, I'm arguing that they are a seismic detector for a point in time when these realms became intermingled more radically than ever before.

It was already hard enough to distinguish production, distribution, and consumption from one another, since each reflects certain aspects of the other two. Any production is also a kind of consumption (for example, of resources), and consumption is also a kind of production (because without use the product is not "completed"); and distribution or circulation produce and consume simultaneously as well. Still, on a common-sense level, we sort of know the approximate difference. Yet in the age of the Internet, of financial markets so complex that the players themselves don't fully understand its mechanisms, and of thoroughly global economic

interdependence, it has become almost impossible to keep them apart. Information circulates so quickly, at such a high rate, and in such quantities that to sort it all out becomes a kind of production process in itself. The fusion of production and consumption has been heralded many times, by accentuating the classical way in which any production is a consumption of sorts, and consumption is always also a way of producing. But consumers of social networking Web sites such as Facebook *are* actually producing something beyond the mere completion or re-contextualization of a product given to them. And distribution or circulation is the very tool of that production. Whether this production is considered beneficial or not depends on many factors that need to be evaluated, which is not my concern here. Rather, I'm concerned with the effects this essentially technological and economic development has on the idea of distinguishable movements.

Classical avant-gardes were about generations in quarrel: Pop art, Minimal, and Conceptual art were not least rejections of the earlier Abstract Expressionism. But today, the idea of generations succeeding each other becomes blurred; as soon as you are willing to enter the circulation, it is possible to re-launch. Avant-gardes, in an odd way, were dependent on information, but also on a *lack* of information: a kind of productive ignorance of the contradiction of their rejections of previous generations, for example. This has become harder and harder: the more these contradictions have been discussed, the more it has become impossible to make the same "productive" mistakes again.

So are we dealing here with a kind of "saturation" of the idea that art could progress? A kind of historic accumulation of already-achieved

expansions and reinventions of what art could be, leaving us feeling stranded amidst the flotsam of these previous achievements piling up in the museums, the libraries, and on the Internet? Evidence that this might be the case comes courtesy of the observation that this experience is not exclusive to art. In pop music, the last "explosions" of new styles were punk in the 1970s and hip-hop and techno in the 1980s; since then, a myriad of styles have been circulating, but none has had a comparable impact. In philosophy, the age of schools seems to be over, too; since the death of Jacques Derrida in 2004, all of the influential movements seem actually to be hybrids of earlier movements, even if they ironically argue for purity and against hybridity, and so on.

But is this really a problem? It is insofar as we demand that art (or philosophy, or pop music) completely re-invent itself once more. The thing is that this re-invention has become seemingly impossible because all these previous re-inventions were built on the possibility of expansion, and once the globe has been saturated with expansion, the only way forward seems to be to shrink backwards.

But we shouldn't forget the well-known allegation against modernism, that it hypostatizes progress and invention, and thus perpetuates the capitalist ideology of newness. The allegation against postmodernism in turn is that it hypostatizes eclecticism and heterogeneity, late capitalism's ideology of pick-'n'-mix consumerism. I think both these allegations are hampered, if not outright wrong.

As for the allegation against modernism: the allegation erases a crucial difference between mere novelty and actual innovation that holds true both for the avant-gardes and for capitalism. You might hate capitalism, its cold mechanical production

of success and annihilation, but you can't ignore
that in its history there have been innovations that
exceeded, sometimes excessively, its own logic—
one could for example argue that the Marxist tradi-
tion is a kind of critique that capitalism inevitably
had to produce; or think, again, of the Internet,
which on the one hand is a brilliant marketing
device, but is at the same time a brilliant means
of sabotaging that very marketing, if necessary. As
Boris Groys has argued, "newness" is the negotia-
tion of the division between what is considered
profane and what is considered valuable.[12]

A similar thing can be said about art move-
ments: at face value, they might "just" be about a
stylistic innovation; but in fact they can foster "real"
structural innovation, sometimes almost as a collat-
eral effect. Think of how conceptual art has changed
the way art is made; the "style" of, for example,
writing up propositions with a typewriter may seem
dated now, but nevertheless the conceptual meth-
odology remains silently present in a great deal of
art made today.

Just as method is not merely style, idea
is not merely novelty. But how do we detect the
difference? For a true idea in the "classic sense"
to emerge, there are usually two contradictory,
telltale signs: it is met with rage and rejection, or it
is completely ignored. In terms of European science,
one could think of Giordano Bruno, who argued that
the universe is endless and the stars we see all
distant suns. We know today that he was completely
right, but in 1600 he was burned at the stake by
the Church in Rome. In modern art, just to take two
obvious examples: the premiere of Igor Stravinsky's
ballet *The Rite of Spring* in 1913 caused a riot, and
the first presentation of Marcel Duchamp's *The
Fountain* (1917), the famous urinal as readymade,

went completely unnoticed—people simply didn't perceive it as a work of art.

Innovative concepts today are still met with rejection and ignorance, or a mixture of both. But usually the information is too readily available and there are too many players for things *not* to find an audience—the most outrageous or unthinkable things will be accepted even if only by a relatively small group, and in this sense, rage and rejection have been replaced by a kind of generalized indifference.

But should that indifference be held against art? Should art try to violently break through indifference by again provoking rage and rejection? Some artists in recent years have tried to do so, usually by way of breaking age-old taboos such as the peace of the dead, or cannibalism. I can think of two obvious Chinese examples: Zhu Yu, who allegedly ate a fetus (*Eating People*, 2000), and Xiao Yu, who exhibited the head of a dead fetus (*Ruan*, 2002). But things that shock can, instead of being avant-garde, be utterly conventional: in the sense that they do nothing but provoke shock based on the *existing* moral or juridical structure. Meanwhile, things that are applauded might be so for the wrong reasons— not for their innovative kernel but for their conventional shell. To answer the question of whether indifference should be held against art: I don't think so. The value of art is not defined by immediate reaction, its true achievement may only be realized much later, in hindsight. So the tell-tale signs of a "new" idea—that it is met with rejection, ignorance, or both—don't really work in a global environment of mass-media saturation. Boris Groys was right in arguing that acceptance of innovation depends on cultural archiving—one can only distinguish and appreciate the new in relation to the old.[13] But what

if that archive becomes so vast that it can't be held in check, if it extends beyond any single human being's capacity? Art has grown exponentially both through time and around the globe. Artistic innovation, it seems, can only be taken forward if it's not so much about finding that one tiny *thing* that hasn't entered the archive of cultural knowledge yet (the fetus meal, for instance), but about finding an innovative way of making use of that archive, or of settling into its cracks and uncharted assets. Innovation for a long time probably relied as much on information as it did on ignorance, or rather the luck of overlooking the right things. It's become rather hard not to be relatively well-informed in a field when, via the Internet and growing archives, almost everything is available at hand.

Just as mere stylistic novelty needs to be distinguished from true structural innovation in the modernist conception, so with postmodernism does true heterogeneity needs to be distinguished from faux heterogeneity. Until quite recently, we could to some extent trust intuition: we knew the difference between a merely folkloristic, superficial demonstration of eclectic pastiche or multicultural harmony, and an actual cross-fertilization of different strands of cultural tradition. It becomes apparent in gesture, in the details of pronunciation, in the actual knowledge. The Internet, however, has changed this. Just as much as it blurs the line between the "now" of novelty and newness and the infinite depth of history and archive, it also blurs the line between fake heterogeneity and true heterogeneity. It has made it possible to produce atomized mutant hybrids between the two: people who are great enough fans will be able to find film footage and sound recordings and images and scholarly discussion of virtually anything on the Internet.

The rock band Gogol Bordello are described as "a multi-ethnic Gypsy punk band from the Lower East Side of New York."

Up until the 1990s, in pop music, we dis-
cussed so-called crossovers between two different
genres such as heavy metal and hip-hop, or punk
and reggae. Today, young bands from, say, Brooklyn,
New York, happily tap into *hundreds* of sources,
New Wave and cheesy middle-of-the-road pop and
African beats and Brazilian bossa nova and English
folk rock and what have you. In art, it's similar. A few
years ago, I wrote an article and made an exhibition
on what I called "Romantic Conceptualism," detect-
ing a strand of conceptual art that had been present
from its inception in the 1960s, but had only become
fully apparent through the contemporary work made
in its wake. In other words, artists had been looking
at the monolithic-seeming last avant-gardes of Pop,
Minimal, and Concept and had started to notice
contradictions and seemingly peripheral figures,
which they explored and put center stage. In the
case of Romantic Conceptualism, the work of artists
such as Bas Jan Ader seemed to call conceptual
art's apparent emphasis on cool rationalism into
question. With regard to the 1990s and up until very
recently, one can speak similarly of Psychedelic
Minimalism, Libidinal Minimalism, Pop Abstrac-
tion. Not to forget the many re-evaluations of older
avant-gardes: looking at constructivist or surrealist
legacies with, for example, the new political land-
scape of Eastern Europe in mind, or re-evaluating
gender and sexual orientation.

To some extent, I think that phase is over.
Now, these re-readings have basically been done.
The upper echelons of the art business may have
always preferred label clarity—an immediately
recognizable visual style—and while this attitude
may persist, it will be less than ever before where
innovation actually occurs. Further mutations and
atomizations will take place that not only question

the distinctions and contradictions between genres and styles, but structurally evaporate the very notion of genre and style. This is actually less "new" than it may seem: since the 1960s, there have been artists such as Bruce Nauman or Mike Kelley or Rosemarie Trockel who absorbed an enormous variety of methodologies, ideas, and styles into their practice. Ai Weiwei is arguably another example. I would argue that this kind of approach, for the first time, will become fully hegemonic. Does that mean all will be ruled by indifference—anything goes, you can present any absurd, multiple combination of things as art? No; it just raises the bar. Amidst the sea of possibilities, in order not to drown, you have to make yourself a raft of whatever you find. It's not the cleanest raft that counts, but the one that takes you the furthest. There are artists such as Ming Wong, a Berlin-based Singaporean artist making wildly eclectic but super-succinct "mutated" remakes of all sorts of scenes from film history; or Roee Rosen, an Israeli artist who—besides actually breaking taboos, in the guise of role-play and parody—leaves no stone unturned in mixing up genres and disciplines and political forms of expression and ways of embarrassing yourself, all to further the cause of art. When I see that kind of work, I think it proves that the perversely hybrid nature of today's cultural and political landscape has had an effect on the tendency of art to settle into one aspect of the triad of production, distribution, and consumption I previously described—now, it seems all three are turned into a wildly whirling medley, and again it's hard to resist the comparison to the Internet's effect of equally blurring the lines between production, distribution, and consumption more radically and fundamentally than ever before.

In an article I wrote a few years ago about

Richard Artschwager—another predecessor of today's freestyle mutationalism—I tried to explain his odd position at the edges of Pop, Minimal, and Concept with an allegory involving people in an office building.[14] In 1981, Artschwager had realized an installation called *Janus* in the Hayden Gallery at MIT in Cambridge, Massachusetts. It made the viewers feel as if they were in a chrome-framed, oak Formica elevator. On pressing the buttons in a panel in the wall, small lights lit up one by one accompanied by the rushing sound of an elevator in motion till the desired floor had been reached. On the basis of this work, it was possible to liken Artschwager's position in the context of Pop, Minimal, and Concept art to that of an elevator in a New York office building, the kind one sees in the opening scene of Billy Wilder's comedy *The Apartment*. Pop artists hang around on the streets and in the lobby, some have their noses pressed against the show windows of boutiques, some are leafing through fashion journals at the newsstand or buying themselves a hot dog at the kiosk. The eyes of the minimalists sweep indifferently across the scene, then travel along the flat and monochromatic grid of the facade all the way to the opaque paneling of the executives' upper floors. The conceptualists are already looking around in the accounts-and-planning department when Artschwager's elevator, paneled with Formica and resonant with surreal Muzak, glides past all the floors—from the lobby past the accounts-and-planning department to the executive floor and down again. Where are the young contemporary artists in this scene? They are taking on all of the roles available, as if they were on loan from a temporary employment company. They are the plumbers and window cleaners, the visiting CEO landing on the roof in a helicopter, the bike courier,

the tourists who go up to the top-floor panorama restaurant. Whether this is all a travesty, or actually leads to something, will hopefully be clearer in a few years' time. In any case, the diagnosis of a "corruption" of art by its conditions in capitalist society is to be taken as a starting point, not as the reason to bewail a final stage.

According to Marx, the fetish commodity, as if by magic, renders the work that went into producing it invisible. In contrast, luxury products often highlight the specialized handicraft that went into producing them. Maybe one of art's jobs is to continue finding ways to position itself like a stoppage in the gap between these two versions of the object, playing them off against each other, even by way of repudiating objecthood itself. This also means preventing consumption and production from being presented as a seamless continuum. Against this background, denouncing the "now" as mere novelty is fruitless: it erases the question of what *is* new, the undeniable existence of, for example, new ways of waging war or torturing, or, just as well, new cures and remedies against diseases. The fact we have to face is that art, probably, is torture and remedy in one.

1
See Peter Bürger, *Theory of the Avant-Garde*, trans. Michael Shaw (Minneapolis: University of Minnesota Press, 1984).

2
See "lollipop," Online Etymology Dictionary. Alternatively, it may be a word of Gypsy origin related to the Roma tradition of selling apples dipped in red candy and placed on a stick, the term for which is "loli phaba" (red apple).

3
See "The History of Lollipop Candy," CandyFavorites.com.

4
Lawrence Alloway, "The Arts and the Mass Media," *Architectural Design* 28 (February 1958): 34–35.

5
See Arthur C. Danto, *The Transfiguration of the Commonplace* (Cambridge, MA: Harvard University Press, 1981).

6
Richard Wollheim, "Minimal Art," *Arts Magazine* (January 1965): 26–32.

7
Robert Morris: "[O]ne is more aware than before that he himself is establishing relationships as he apprehends the object from varying positions and under varying conditions." Robert Morris, "Notes on Sculpture II," *Artforum* 5, no. 2 (October 1966): 21.

8
See Jacques Rancière, *The Politics of Aesthetics: The Distribution of the Sensible* (London, New York: Continuum, 2006).

9
See http://www.henryflynt.org/meta_tech/crystal.html.

10
Sol LeWitt, "Paragraphs on Conceptual Art," *Artforum* 5, no. 10, (Summer 1967), 78–83.

11
Reproduced in *Art in Theory 1900–2000: An Anthology of Changing Ideas*, ed. Charles Harrison and Paul J. Wood (Oxford: Blackwell Publishing Ltd, 1992), 894.

12
Boris Groys, "On the New" in *Art Power* (Cambridge, MA: The MIT Press, 2008), 22–42.

13
Boris Groys, "Multiple Authorship" in *Art Power* (Cambridge, MA: The MIT Press, 2008), 92–100.

14
Jörg Heiser, "Elevator. Richard Artschwager in the Context of Minimal, Pop and Concept Art," *Richard Artschwager: The Hydraulic Doorcheck*, ed. Peter Noever (Cologne: Verlag der Buchhandlung Walther König and MAK Vienna, 2003), 49–60.

Martha Rosler

Take the Money and Run? Can Political and Socio-Critical Art "Survive"?

Just a few months before the real estate market brought down much of the world economy, taking the art market with it, I was asked to respond to the question whether "political and socio-critical art" can survive in an overheated market environment. Two years on, this may be a good moment to revisit the parameters of such work (now that the fascination with large-scale, bravura, high wow-factor work, primarily in painting and sculpture, has cooled—if only temporarily).

Categories of criticality have evolved over time, but their taxonomic history is short. The naming process is itself frequently a method of recuperation, importing expressions of critique into the system being criticized, freezing into academic formulas things that were put together off the cuff. In considering the long history of artistic production in human societies, the question of "political" or "critical" art seems almost bizarre; how shall we characterize the ancient Greek plays, for example? Why did Plato wish to ban music and poetry from his Republic? What was to be understood from English nursery rhymes, which we now see as benign jingles? A strange look in the eye of a character in a Renaissance scene? A portrait of a duke with a vacant expression? A popular print with a caricature of the king? The buzz around works of art is surely less now than when art was not competing with other forms of representation and with a wide array of public narratives; calling some art "political" reveals the role of particular forms of thematic enunciation.[1] Art, we may now hear, is meant to speak past particular understandings or narratives, and all the more so across national borders or creedal lines. Criticality that manifests as a subtle thread in iconographic details is unlikely to be apprehended by wide audiences across national

Martha Rosler

borders. The veiled criticality of art under repressive regimes, generally manifesting as allegory or symbolism, needs no explanation for those who share that repression, but audiences outside that policed universe will need a study guide. In either case, it is not the general audience but the educated castes and professional artists or writers who are most attuned to such hermeneutics. I expand a bit on this below. But attending to the present moment, the following question from an intelligent young scenester may be taken as a tongue-in-cheek provocation rooted in the zeitgeist, reminding us that political and socio-critical art is at best a niche production:

> We were talking about whether choosing to be an artist means aspiring to serve the rich. . . . that seems to be the dominating economic model for artists in this country. The most visible artists are very good at serving the rich. . . . the ones who go to Cologne to do business seem to do the best. . . . She told me this is where Europe's richest people go

Let us pause to think about how art first became characterized by a critical dimension. The history of such work is often presented in a fragmented, distorted fashion; art that exhibits an imperfect allegiance to the ideological structures of social elites has often been poorly received.[2] Stepping outside the ambit of patronage or received opinion without losing one's livelihood or, in extreme situations, one's life, became possible for painters and sculptors only a couple of hundred years ago, as the old political order crumbled under the changes wrought by the Industrial Revolution, and direct

Vittore Carpaccio, *Two Venetian Ladies*, c. 1490. Oil on Panel, 37" × 25".

patronage and commissions from the Church and aristocrats declined.³

Members of the ascendant new class, the bourgeoisie, as they gained economic and political advantage over previous elites, also sought to adopt their elevated cultural pursuits; but these new adherents were more likely to be customers than patrons.⁴ Artists working in a variety of media and cultural registers, from high to low, expressed positions on the political ferment of the early Industrial Revolution. One might find European artists exhibiting robust support for revolutionary ideals or displaying identification with provincial localism, with the peasantry or with the urban working classes, especially using fairly ephemeral forms (such as the low-cost prints available in great numbers); smiling bourgeois subjects were depicted as disporting and bettering themselves while decked out in the newest brushstrokes and modes of visual representation. New forms of subjectivity and sensibility were defined and addressed in different modalities (the nineteenth century saw the development of popular novels, mass-market newspapers, popular prints, theater, and art), even as censorship, sometimes with severe penalties for transgression, was sporadically imposed from above.

The development of these mass audiences compelled certain artists to separate themselves from mass taste, as Pierre Bourdieu has suggested,⁵ or to waffle across the line. Artistic autonomy, framed as a form of insurgency, came to be identified by a military term, the *avant-garde*, or its derivative, the vanguard.⁶ In times of revanchism and repression, of course, artists assert independence from political ideologies and political masters through ambiguous or allegorical structures—critique by indirection. Even

manifestoes for the freeing of the poetical Imagination, a potent element of the burgeoning Romantic movements, might be traced to the transformations within entrenched ideology and of sensibility itself as an attribute of the "cultivated" person. The expectation that "advanced" or vanguard art would be autonomous—independent of direct ideological ties to patrons—created a predisposition toward the privileging of its formal qualities. Drawing on the traditions of Romanticism, it also underlined its insistence on subjects both more personal and more universal—but rooted in the experiential world, not in churchly dogmas of salvation.[7] The poetic imagination was posited as a form of knowing that vied with materialist, rationalist, and "scientific" epistemologies—one superior, moreover, in negotiating the utopian reconception and reorganization of human life.[8] The Impressionist painters, advancing the professionalization of art beyond the bounds of simple craft, developed stylistic approaches based on interpretations of advanced optical theory, while other routes to inspiration, such as psychotropic drugs, remained common enough. Artistic avant-gardes even at their most formal retained a utopian horizon that kept their work from being simply exercises in decor and arrangement; disengagement from recognizable narratives, in fact, was critical in advancing the claims of art to speak of higher things from its own vantage point or, more specifically, from the original and unique point of view of individual, named producers. Following John Fekete, we may interpret the positive reception of extreme aestheticism or "art for art's sake" as a panicked late-nineteenth-century bourgeois response to a largely imaginary siege from the political left.[9] But even such aestheticism, in its demand for absolute disengagement, offered a possible

opening to an implied political critique, through the abstract, Hegel-derived, social negativity that was later a central element of the Frankfurt School, as exemplified by Adorno's insistence, against Brecht and Walter Benjamin, that art in order to be appropriately negative must remain autonomous, above partisan political struggles.

The turn of the twentieth century, a time of prodigious industrialization and capital formation, witnessed population flows from the impoverished European countryside to sites of production and inspired millenarian conceits that impelled artists and social critics of every stripe to imagine the future. We may as well call this modernism. And we might observe, briefly, that modernism (inextricably linked, needless to say, to modernity) incorporates technological optimism and its belief in progress, while antimodernism sees the narrative of technological change as a tale of broad civilizational decline, and thus tends toward a romantic view of nature.

Art history allows that in revolutionary Russia many artists mobilized their skills to work toward the socially transformative goals of socialist revolution, adopting new art forms (film) and adapting older ones (theater, poetry, popular fiction, and traditional crafts such as sewing and china decorating, but in mechanized production), while others outside the Soviet Union expressed solidarity with worldwide revolution. In the United States and Europe, in perhaps a less lauded—though increasingly documented—history, there were proletarian and communist painters, writers, philosophers, poets, photographers

Photographic modernism in the United States (stemming largely from Paul Strand, but with something of a trailing English legacy), married a

documentary impulse to formal innovation. It inevitably strayed into the territory of Soviet and German photographic innovators, many of whom had utopian socialist or communist allegiances, although few of the American photographic modernists aside from Strand shared these political viewpoints. Pro-ruralist sentiments were transformed from backward-looking, romantic, pastoral longing to a focus on labor (perhaps with a different sort of romanticism) and on workers' milieux, both urban and rural.[10]

The turn of the century brought developments in photography and printing (such as the new photo-lithographic printing technology of 1890 and the new small cameras, notably the Leica in 1924) that gave birth to photojournalism and facilitated political agitation. The "social documentary" impulse is not, of course, traceable to technology, and other camera technologies, although more cumbersome, were also employed.[11] Many photographers were eager to use photographs to inform and mobilize political movements—primarily by publishing their work in the form of journal and newspaper articles and photo essays. In the early part of the century, until the end of the 1930s, photography was used to reveal the processes of State behind closed doors (Erich Salomon); to offer public exposés of urban poverty and degradation (Lewis Hine, Paul Strand; German photographers like Alfred Eisenstaedt or Felix Mann who were working for the popular photo press); to provide a dispassionate visual "anatomization" of social structure (August Sander's interpretation of *Neue Sachlichkeit*, or New Objectivity); to serve as a call to arms, both literally (the newly possible war photography, such as that by Robert Capa, Gerda Taro, David Seymour) and figuratively (the activist photo and newsreel groups in various

Martha Rosler

countries, such as the Workers Film and Photo leagues in various U.S. cities); and to support government reforms (in the United States, Roosevelt's Farm Security Administration). Photography, for these and other reasons, is generally excluded from standard art histories, which thoroughly skews the question of political commitment or critique.[12] In the contemporary moment, however, the history of photography is far more respectable, since photography has become a favored contemporary commodity and needs a historical tail (which itself constitutes a new market); but the proscription of politically engaged topicality is still widespread.[13]

European-style avant-gardism made a fairly late appearance in the United States, but its formally inscribed social critique offered, approximately from the 1930s through the late 1940s, an updated, legible version of the antimaterialist, and eventually anticonsumerist, critique previously offered by turn-of-the-twentieth-century anti-modernism. Modernism is, inter alia, a conversation about progress, the prospects of utopia, and the fear, doubt, and horror over the costs of modernization and modernity, especially as seen from the vantage point of the members of the intellectual class. One strand of modernism led to Futurism's catastrophic worship of the machine and war (and eventually to political fascism) but also to utopian urbanism and International Style architecture.[14]

Modernism notoriously exhibited a kind of ambiguity or existential angst—typical problems of intellectuals, one imagines, whose identification, if any, with workers, peasants, and proletarianized farm workers is maintained almost wholly by sheer force of conviction in the midst of a very different way of life—perhaps linked experientially by related, though very different, forms of alienation.

Such hesitancy, suspicion, or indifference is a fair approximation of independence—albeit blessedly well-behaved in not screaming for revolution—but modernism, as suggested earlier, was suffused with a belief in the transformative power of (high) art. What do (most) modern intellectual elites do if not distance themselves from power and express suspicion, sometimes bordering on despair, of the entire sphere of life and mass cultural production (the ideological apparatuses, to borrow a term from Althusser)?[15]

Enlightenment beliefs in the transformative power of culture, having recovered from disillusionment with the French Revolution, which had led to the Terror, were again shattered by the monstrosity of trench warfare and aerial bombing in the First World War (as with the millenarianism of the present century, that of the turn of the twentieth century was smashed by war). Utopian hopes for human progress were revived along with the left-leaning universalism of interwar Europe but were soon to be ground under by the Second World War. The successive "extra-institutional" European avant-garde movements that had challenged dominant culture and industrial exploitation between the wars, notably Dada and Surrealism, with their very different routes to resisting social domination and bourgeois aestheticism, had dissipated before the war began. Such dynamic gestures and outbursts are perhaps unsustainable as long-term movements, but they have had continued resonance in modern moments of criticality.

Germany had seen itself as the pinnacle of Enlightenment culture; its wartime barbarism, including the Nazis' perverse, cruel, totalitarian re-imaginings of German history and culture, was an especial blow to the belief in the transcendent

Martha Rosler

powers of culture. Postwar Europe had plenty to be critical about, but it was also staring into the abyss of existentialist angst and the loneliness of *Being and Nothingness* (and Year Zero). In Western(ized) cultures during the postwar period, a world-historical moment centering on nuclear catastrophism, communist Armageddon, and postcoloniality (empire shift), the art that seemed best equipped to carry the modernist burden was abstract painting, with its avoidance of incident in favor of formal investigations and a continued search for the sublime. In a word, it was painting by professionals, communicating in codes known only to the select few, in a conscious echo of other professional elites, such as research scientists (a favorite analogy among its admirers). Abstract painting was both serious and impeccably uninflected with political imagery, unlike the social realism of much of American interwar painting. As cultural hegemony was passing from France to the United States, critical culture was muted, taking place mostly at the margins, among poets, musicians, novelists, and a few photographers and social philosophers, including the New York School poets and painters, among them those who came to be called Abstract Expressionists.

The moment was brief: the double-barreled shotgun of popular recognition and financial success brought Abstract Expressionism low. Any art that depends on critical distance from social elites—but especially an art associated rhetorically with transcendence, which presupposes, one should think, a search for authenticity and the expectations of approaching it—has trouble defending itself from charges of capitulation to the prejudices of a clientele. For Abstract Expressionism, with its necessary trappings of authenticity,

grand success was untenable. Suddenly well capitalized, as well as lionized, as a high-class export by sophisticated government internationalists, and increasingly "appreciated" by mass-culture outlets, the Abstract Expressionist enclave, a bohemian mixture of native-born and émigré artists, fizzled into irrelevance, with many of its participants prematurely dead.

Abstract Expressionism, like all modernist high culture, was understood to be a critical art, yet it appeared, against the backdrop of ebullient democratic/consumer culture, as detached from the concerns of the everyday. How can there be poetry after Auschwitz, or, indeed, *pace* Adorno, after television? Bohemia itself (that semi-artistic, semi-intellectual subculture, voluntarily impoverished, disaffected, and anti-bourgeois) could not long survive the changed conditions of cultural production and, indeed, the pattern of daily life in the postwar West. Peter Bürger's canonical thesis on the failure of the European avant-gardes in prewar Europe has exercised a powerful grip on subsequent narratives of the always-already-dead avant-gardes.[16] As I have written elsewhere, expressionism, Dada, and Surrealism were intended to reach beyond the art world to disrupt conventional social reality and thereby become instruments of liberation. As Bürger suggests, the avant-garde intended to replace individualized production with a more collectivized and anonymous practice and simultaneously to evade the individualized address and restricted reception of art.[17] The art world was not destroyed as a consequence—far from it: as Bürger notes, the art world, in a maneuver that has become familiar, swelled to encompass the avant-gardes, and their techniques of shock and transgression were absorbed as the production of the new.[18] *Anti-art* became *Art*, to use

the terms set in opposition by Allan Kaprow in the early 1970s, in his (similarly canonical) articles in *ArtNews* and *Art in America* on "the education of the un-artist."[19]

In the United States, at least, after the war the search for authenticity was reinterpreted as a search for privatized, personal self-realization, and there was general impatience with aestheticism and the sublime. By the end of the 1950s, dissatisfaction with life in McCarthyist, "conformist" America—in segregated, male-dominated America—rose from a whisper, cloistered in little magazines and journals, to a hubbub. More was demanded of criticality— and a lot less.

Its fetishized concerns fallen by the wayside, Abstract Expressionism was superseded by Pop art, which—unlike its predecessor—stepped onto the world stage as a commercially viable mode of artistic endeavor, unburdened by the need to be anything but flamboyantly inauthentic, eschewing nature for human-made (or, more properly, corporate) "second nature." Pop, as figured in the brilliant persona of Andy Warhol—in many ways the Michael Jackson of the 1960s—gained adulation from the masses by appearing to flatter them while spurning them. For buyers of Campbell Soup trash cans, posters of Marilyn or Jackie multiples, and banana decals, no insult was apprehended nor criticism taken, just as the absurdist costumes of Britain's mods and rockers, or even, later, the clothing fetishes of punks or hip-hop artists, or of surfers or teen skateboarders, were soon enough taken as cool fashion cues by many adult observers—even those far from the capitals of fashion, in small towns and suburban malls.[20]

The 1960s were a robust moment, if not of outspoken criticality in art, then of artists' unrest,

Take the Money and Run? Can Political and Socio-Critical Art "Survive"?

Martha Rosler

while the culture at large, especially the "civil rights/ youth culture/counterculture/antiwar movement," was more than restive, attempting to re-envision and remake the cultural and political landscape. Whether they abjured or expressed the critical attitudes that were still powerfully dominant in intellectual culture, artists were chafing against what they perceived as a lack of autonomy, made plain by the grip of the market, the tightening noose of success (though still nothing in comparison to the powerful market forces and institutional professionalization at work in the current art world). In the face of institutional and market ebullience, the 1960s saw several forms of revolt by artists against commodification, including deflationary tactics against glorification. One may argue about each of these efforts, but they nevertheless asserted artistic autonomy from dealers, museums, and markets, rather than, say, producing fungible items in a signature brand of object production. So-called "dematerialization": the production of low-priced, often self-distributed multiples; collaborations with scientists (a continued insistence on the experimentalism of unfettered artistic imagination); the development of multimedia or intermedia and other ephemeral forms such as smoke art or performances that defied documentation; dance based on ordinary movements; the intrusion or foregrounding of language, violating a foundational modernist taboo, and even the displacement of the image by words in Wittgensteinian language games and conceptual art; the use of mass-market photography; sculpture made of industrial elements; earth art; architectural deconstructions and fascinations; the adoption of cheap video formats; ecological explorations; and, quite prominently, feminists' overarching critique . . . all these resisted the special material valuation of

Take the Money and Run? Can Political and Socio-Critical Art "Survive"?

Martha Rosler

the work of art above all other elements of culture, while simultaneously disregarding its critical voice and the ability of artists to think rationally without the aid of interpreters. These market-resistant forms (which were also of course casting aside the genre boundaries of Greenbergian high modernism), an evasive relation to commodity and profession-alization (careers), carried forward the questioning of craft. The insistence on seeing culture (and, perhaps more widely, human civilization) as primar-ily characterized by rational choice—see under conceptualism—challenged isolated genius as an essential characteristic of artists and furthered the (imaginary) alignment with workers in other fields. These were not arts of profoundly direct criticality of the social order.

An exception is art world feminism, which, beginning in the late 1960s, as part of a larger, vigorously critical and political movement, offered an overt critique of the received wisdom about the characteristics of art and artists and helped mount ultimately successful challenges to the reigning paradigm by which artists were ranked and interpretation controlled. Feminism's far-reaching critique was quite effective in forcing all institu-tions, whether involved in education, publicity, or exhibition, to rethink *what* and *who* an artist is and might be, what materials art might be made of, and what art *meant* (whether that occurred by way of overt signification or through meaning sedimented into formal expectations), replacing this with far broader, more heterodox, and dynamic categories. Whether feminist work took the form of trenchant social observation or re-envisioned formal approaches such as pattern painting, no one failed to understand critiques posed by works still seen as embedded in their social matrix (thus rekindling,

however temporarily, a wider apprehension of coded "subtexts" in even non-narrative work).

Another exception to the prevailing reactive gambits in 1960s art was presented by two largely Paris-based neo-Dada, neo-Surrealist avant-garde movements, Lettrism and the Situationist International (SI), both of which mounted direct critiques of domination in everyday life. The SI eventually split, in good measure over whether to cease all participation in the art world, with founding member Guy Debord, a filmmaker and writer, among those who chose to abandon that milieu.[21] Naturally, this group of rejectionists is the SI group whose appreciation in the art world was revived in the 1980s following a fresh look at Debord's Society of the Spectacle (1967). The book proposes to explain, in an elegant series of numbered statements or propositions, how the commodity form has evolved into a spectacular world picture; in the postwar world, domination of the labor force (most of the world's people) by capitalist and state capitalist societies is maintained by the constant construction and maintenance of an essentially false picture of the world retailed by all forms of media, but particularly by movies, television, and the like. The spectacle, he is at pains to explain, is a relationship among people, not among images, thus offering a materialist, Marxist interpretation. Interest in Debord was symptomatic of the general trend toward a new theoretical preoccupation with (in particular) media theory, in post-Beaux Arts, post-Bauhaus, postmodern art education in the United States beginning in the late 1970s. The new art academicism nurtured criticality in art and other forms of theory-driven production, since artists were being officially trained to teach art as a source of income to fund their production rather than simply to find markets.[22]

There had been a general presumption among postwar government elites and their organs (including the Ford Foundation) that nurturing "creativity" in whatever form was good for the national brand; predispositions toward original research in science and technology and art unencumbered by prescribed messages were potent symbols of American freedom (of thought, of choice . . .), further troubling artists' rather frantic dance of disengagement from market and ideological mechanisms throughout the sixties. In the United States in the late 1960s, President Johnson's Great Society included an expansive vision of public support for the arts. In addition to direct grants to institutions, to critics, and to artists, nonprofit, artist-initiated galleries and related venues received Federal money. This led to a great expansion of the seemingly uncapitalizable arts like performance and video, whose main audience was other artists. Throughout the 1970s, the aligned network of media, museum, and commercial gallery were deployed in attempts to limit artists' autonomy, bring them back inside the institutions, and recapitalize art.[23] A small Euro-American group of dealers, at the end of the decade, successfully imposed a new market discipline by instituting a new regime of very large, highly salable neo-expressionist painting, just as Reaganism set out to cripple, if not destroy, public support for art. Art educators began slowly adopting the idea that they could sell their departments and schools as effective in helping their students find gallery representation by producing a fresh new line of work. The slow decline of "theoretical culture"—in art school, at least—had begun.

The Right-Republican assault on relatively autonomous symbolic expression that began in the mid-1980s and extended into the 1990s became

known as the "culture wars"; it continues, although with far less prominent attacks on art than on other forms of cultural expression.[24] Right-wing elites managed to stigmatize and to restrict public funding of certain types of art. Efforts to brand some work as "communist," meaning politically engaged or subversive of public order, no longer worked by the 1980s. Instead, U.S. censorship campaigns have mostly taken the form of moral panics meant to mobilize authoritarian-minded religious fundamentalists in the service of destroying the narrative and the reality of the liberal welfare state, of "community," echoing the "degenerate art" smear campaigns of the Nazis. Collectors and some collecting institutions perceived the *éclat* of such work—which thematized mostly sex and sexual inequality (in what came to be called "identity politics") as opposed to, say, questions of labor and governance, which were the targets in earlier periods of cultural combat—as a plus, with notoriety no impediment to fortune.[25] The most vilified artists in question have not suffered in the marketplace; on the contrary. But most public exhibiting institutions felt stung and reacted accordingly—by shunning criticality, since their funding and museum employment were tied to public funding. Subsequent generations of artists, divining that "difficult" content might restrict their entry into the success cycle, have engaged in self-censorship. Somewhat perversely, the public success of the censorship campaigns stems partly from the myth of a classless, unitary culture: the pretense that in the United States, art and culture belong to all and that very little specific knowledge or education is, or should be, necessary for understanding art. But legibility itself is generally a matter of education, which addresses a relatively small audience already equipped with appropriate tools

Take the Money and Run? Can Political and Socio-Critical Art "Survive"?

Martha Rosler

of decipherment, as I have claimed throughout the present work and elsewhere.

But there is another dimension to this struggle over symbolic capital. The art world has expanded enormously over the past few decades and unified to a great degree, although there are still local markets. This market is "global" in scope and occupied with questions very far from whether its artistic practices are political or critical. But thirty years of theory-driven art production and critical reception—which brought part of the discursive matrix of art inside the academy, where it was both shielded from and could appear to be un-implicated in the market, thereby providing a cover for direct advocacy—helped produce artists whose practices were themselves swimming in a sea of criticality and apparently anti-commodity forms.[26] The term "political art" reappeared after art world commentators used it to ghettoize work in the 1970s, with some hoping to grant such work a modicum of respectability while others wielded it dismissively, but for the most part its valence was drifting toward positive. Even better were other, better-behaved forms of "criticality," such as the nicely bureaucratic-sounding "institutional critique" and the slightly more ominous "interventionism." I will leave it to others to explore the nuances of these (certainly meaningful) distinctions, remarking only that the former posits a location within the very institutions that artists were attempting to outwit in the 1960/70s, whereas the latter posits its opposite, a motion outside the institution—but also staged from within. These, then, are not abandonments of art world participation but acceptance that these institutions are the proper—perhaps the only—platform for artists.[27] A further sign of such institutionality is the emergence of a curatorial

subgenre called "new institutionalism" (borrowing a term from a wholly unrelated branch of sociology) that encompasses the work of sympathetic young curators wishing to make these "engaged" practices intramural.

This suggests a broad consensus that the art world, as it expands, is a special kind of sub-universe (or parallel universe) of discourses and practices whose walls may seem transparent but which floats in a sea of larger cultures. That may be the means of coming to terms with the overtaking of high-cultural meaning by mass culture and its structures of celebrity, which had sent 1960s artists into panic. Perhaps artists are now self-described art workers, but they also hope to be privileged members within their particular sphere of culture, actually "working"—like financial speculators—relatively little, while depending on brain power and salesmanship to score big gains. Seen in this context, categories like political art, critical art, institutional critique, and interventionism are ways of slicing and dicing the offspring of art under the broad rubric of conceptualism—some approaches favor analyses and symbolic "interventions" into the institutions in question, others more externalized, publicly visible actions.

Perhaps a more general consideration of the nature of work itself and of education is in order. I have suggested that we are witnessing the abandonment of the model of art education as a search for meaning (and of the liberal model of higher education in general) in favor of what has come to be called the success model . . . "Down with critical studies!" Many observers have commented on the changing characteristics of the international work force, with especial attention to the "new flexible personality," an ideal worker type for a life

without job security, one who is able to construct a marketable personality and to persuade employers of one's adaptability to the changing needs of the job market. Commentators like Brian Holmes (many of them based in Europe) have noted the applicability of this model to art and intellectuals.[28] Bill Readings, until his death a Canadian professor of comparative literature at the Université de Montréal, in his posthumously published book, *The University in Ruins* (1997), observes that universities are no longer "guardians of the national culture" but effectively empty institutions that sell an abstract notion of excellence.[29] The university, Readings writes, is "an autonomous bureaucratic corporation" aimed at educating for "economic management" rather than "cultural conflict." The Anglo-American urban geographer David Harvey, reviewing Readings' book in the *Atlantic Monthly*, noted that the modern university "no longer cares about values, specific ideologies, or even such mundane matters as learning how to think. It is simply a market for the production, exchange, and consumption of useful information—useful, that is, to corporations, governments, and their prospective employees."[30] In considering the "production of subjectivity" in this context, Readings writes—citing the Italian philosopher Giorgio Agamben—that it is no longer a matter of either shop-floor obedience or managerial rationality but rather the much touted "flexibility," "personal responsibility," "communication skills," and other similarly "abstract images of affliction."[31]

Agamben has provocatively argued that most of the world's educated classes are now part of the new planetary petite bourgeoisie, which has dissolved all social classes, displacing or joining the old petite bourgeoisie and the urban proletariat and inheriting their economic vulnerability. In this

end to recognizable national culture, Agamben sees a confrontation with death out of which a new self-definition may be born—or not. Another Italian philosopher, Paolo Virno, is also concerned with the character of the new global workforce in the present post-Fordist moment, but his position takes a different tack in works like *The Grammar of the Multitude,* a slim book based on his lectures.[32]

> The affinity between a pianist and a waiter, which Marx had foreseen, finds an unexpected confirmation in the epoch in which all wage labor has something in common with the "performing artist." The salient traits of post-Fordist experience (servile virtuosity, exploitation of the very faculty of language, unfailing relation to the "presence of others," etc.) postulate, as a form of conflictual retaliation, nothing less than a radically new form of democracy.[33]

Virno argues that the new forms of globalized "flexible labor" allow for the creation of new forms of democracy. The long-established dyads of public/private and collective/individual no longer have meaning, and collectivity is enacted in other ways. The multitude and immaterial labor produce subjects who occupy "a middle region between 'individual and collective'" and so have the possibility of engineering a different relationship to society, state, and capital. It is tempting to assign the new forms of communication to this work of the creation of "a radically new form of democracy."

Let us tease out of these accounts of the nature of modern labor—in an era in which business types (like Richard Florida) describe the desired work force, typically urban residents, as "creatives"—some observations about artists-in-

training: art students have by now learned to focus not on an object-centered brand signature so much as on a personality-centered one. The cultivation of this personality is evidently seen by some anxious school administrators—feeling pressure to define "art" less by the adherence of an artist's practice to a highly restricted discourse and more in the terms used for other cultural objects—as hindered by critical studies and only to be found behind a wall of craft. (*Craft* here is not to be understood in the medieval sense, as bound up in guild organization and the protection of knowledge that thereby holds down the number of practitioners, but as reinserted into the context of individualized, bravura production—commodity production in particular.) Class and study time give way to studio preparation and exposure to a train of invited, and paid, reviewers/critics (with the former smacking of boot camp, and the latter sending up whiffs of corruption).

It might be assumed that we art world denizens, too, have become neoliberals, finding validation only within the commodity-driven system of galleries, museums, foundations, and magazines, and in effect competing across borders (though some of us are equipped with advantages apart from our artistic talents), a position evoked at the start of this essay in the question posed by an artist in his twenties concerning whether it is standard practice for ambitious artists to seek to sell themselves to the rich in overseas venues.

But now consider the art world as a community—in Benedict Anderson's terms, an imagined community—of the most powerful kind, a postnational one kept in ever-closer contact by emerging systems of publicity and communication alongside other, more traditional print journals, publicity releases, and informal organs (although it

does not quite achieve imaginary nationhood, which is Anderson's true concern).[34]

The international art world (I am treating it here as a system) is entering into the globalizing moment of "flexible accumulation"—a term preferred by some on the left to "(economic) postmodernism" as a historical periodization. After hesitating over the new global image game (in which the main competition is mass culture), the art world has responded by developing several systems for regularizing standards and markets. Let me now take a minute to look at this newly evolving system itself.[35]

The art world had an earlier moment of internationalization, especially in the interwar period, in which International Style architecture, design, and art helped unify the look of elite cultural products and the built environment of cities around the globe. Emergent nationalisms modified this only somewhat, but International Style lost favor in the latter half of the twentieth century. In recent times, under the new "global" imperative, three systemic developments have raised art world visibility and power. First, localities have sought to capitalize on their art world holdings by commissioning buildings from celebrity architects. But high-profile architecture is a minor, small-scale maneuver, attracting tourists, to be sure, but functioning primarily as a symbolic assertion that that particular urban locale is serious about being viewed as a "player" in the world economic system. The Bilbao effect is not always as powerful as hoped. The era of blockbuster shows— invented in the 1970s to draw in crowds, some say by the recently deceased Thomas P. F. Hoving in his tenure at New York's Metropolitan Museum of Art—may be drawing to a close, saving museums from ever-rising expenditures on collateral costs

Take the Money and Run? Can Political and Socio-Critical Art "Survive"?

Martha Rosler

such as insurance; it is the container more than the contents that is the attractant.

More important have been the two other temporary but recurrent, processual developments. First came the hypostatizing biennials of the 1990s. Their frantic proliferation has elicited derision, but these international exhibitions were a necessary moment in the integration of the art system, allowing local institutional players to put in their chips. The biennials have served to insert an urban locale, often of some national significance, into the international circuit, offering a new physical site attracting art and art world members, however temporarily. That the local audience is educated about new international style imperatives is a secondary effect to the elevation of the local venue itself to what might crudely be termed "world class" status; for the biennials to be truly effective, the important audience must arrive from elsewhere. The biennial model provides not only a physical circuit but also a regime of production and normalization. In "peripheral" venues it is not untypical for artists chosen to represent the local culture to have moved to artist enclaves in fully "metropolitan," "first world" cities (London, New York, Berlin, Paris—regarded as portals to the global art market/system), before returning to their countries of origin to be "discovered." The airplane allows a continued relationship with the homeland; expatriation can be prolonged, punctuated by time back home. This condition, of course, defines migrant and itinerant labor of all varieties under current conditions, as it follows the flow of capital."[36]

I recently received a lengthy, manifesto-style e-mail, part of an "open letter to the Istanbul Biennial," that illustrates the critique of biennials with pretensions to political art (characteristic also of

the past three iterations of documenta—a "penten-nial" or "quinquennial" if you will, rather than a biennial—in Kassel, Germany).[37] It is signed by a group calling itself the Resistanbul Commissariat of Culture:

> We have to stop pretending that the popularity of politically engaged art within the museums and markets over the last few years has anything to do with really changing the world. We have to stop pretending that taking risks in the space of art, pushing boundaries of form, and disobeying the conventions of culture, making art about politics makes any difference. We have to stop pretending that art is a free space, autonomous from webs of capital and power. . . .
>
> We have long understood that the Istanbul Biennial aims at being one of the most politically engaged transnational art events. . . . This year the Biennial is quoting comrade Brecht, dropping notions such as neoliberal hegemony, and riding high against global capitalism. We kindly appreciate the stance but we recognize that art should have never existed as a separate category from life. Therefore we are writing you to stop collaborating with arms dealers. . . .
>
> The curators wonder whether Brecht's question "What Keeps Mankind Alive" is equally urgent today for us living under the neoliberal hegemony. We add the question: "What Keeps Mankind Not-Alive?" We acknowledge the urgency in these times when we do not have the right to work, we do not get free healthcare and education, our right to our cities, our squares, and streets are taken by corporations, our land, our seeds and water are stolen, we are driven into precarity and a life without security, when we are killed

Take the Money and Run? Can Political and
Socio-Critical Art "Survive"?

Martha Rosler

crossing their borders and left alone to live an uncertain future with their potential crises. But we fight. And we resist in the streets not in corporate spaces reserved for tolerated institutional critique so as to help them clear their conscience. We fought when they wanted to kick us out of our neighborhoods. . . .

The message goes on to list specific struggles in Turkey for housing, safety, job protections, and so on, which space limitations constrain me to omit.[38] I was interested in the implied return of the accusation that sociocritical/political work is boring and negative, addressed further in this e-mail:

The curators also point out that one of the crucial questions of this Biennial is "how to 'set pleasure free,' how to regain revolutionary role of enjoyment." We set pleasure free in the streets, in our streets. We were in Prague, Hong Kong, Athens, Seattle, Heilegendamm [sic], Genoa, Chiapas and Oaxaca, Washington, Gaza and Istanbul![39] Revolutionary role of enjoyment is out there and we cherish it everywhere because we need to survive and we know that we are changing the world with our words, with our acts, with our laughter. And our life itself is the source of all sorts of pleasure.

The Resistanbul Commissariat of Culture message ends as follows:

Join the resistance and the insurgence of imagination! Evacuate corporate spaces, liberate your works. Let's prepare works and visuals (poster, sticker, stencil etc.) for the streets of the resistance days. Let's produce together, not within the white cube, but in the streets and squares during

the resistance week! Creativity belongs to each and every one of us and can't be sponsored. Long live global insurrection!

This "open letter" underlines the criticism to which biennials or any highly visible exhibitions open themselves when they purport to take on political themes, even if participants and visitors are unlikely to receive such e-mailed messages.[40] As the letter implies, dissent and dissidence that fall short of insurrection and unruliness are quite regularly incorporated into exhibitions, as they are into institutions such as universities in liberal societies; patronizing attitudes, along the lines of "Isn't she pretty when she's angry!" are effective—even President Bush smilingly called protesters' shouts a proof of the robustness of "our" freedom of speech while they were being hustled out of the hall where he was speaking. But I suggest that the undeniable criticisms expressed by Resistanbul do not, finally, invalidate the efforts of institutional reform, however provisional. All movements against an institutional consensus are dynamic, and provisional. (And see below.)

Accusations of purely symbolic display, of hypocrisy, are easily evaded by turning to, finally, the third method of global discipline, the art fair, for fairs make no promises other than sales and parties; there is no shortage of appeals to pleasure. There has been a notable increase in the number and locations of art fairs in a short period, reflecting the art world's rapid monetization; art investors, patrons, and clientele have shaken off the need for internal processes of quality control in favor of speeded-up multiplication of financial and prestige value. Some important fairs have set up satellite branches elsewhere.[41] Other important fairs are

Take the Money and Run? Can Political and
Socio-Critical Art "Survive"?

Martha Rosler

satellites that outshine their original venues and
have gone from the periphery of the art world's vet-
ting circuit to center stage. At art fairs, artworks are
scrutinized for financial-portfolio suitability, while
off-site fun (parties and dinners), fabulousness
(conspicuous consumption), and non-art shop-
ping are the selling points for the best-attended
fairs—those in Miami, New York, and London (and of
course the original, Basel). Dealers pay quite a lot to
participate, however, and the success of the fair as
a business venture depends on the dealers' ability
to make decent sales and thus to want to return in
subsequent years.

No discursive matrix is required for success-
ful investments by municipal and national hosts
in this market. Yet art fairs have delicately tried to
pull a blanket of respectability over the naked profit
motive, by installing a smattering of curated exhibi-
tions among the dealers' booths and hosting on-site
conferences with invited intellectual luminaries. But
perhaps one should say that discursive matrices are
always required, even if they take the form of books
and magazines in publishers' fair booths; but intel-
lectuals talking in rooms and halls and stalking the
floor—and being interviewed—can't hurt.

Predictions about the road to artistic success
in this scene are easy to make, because ultimately
shoppers are in for a quick fix (those Russians!) and
increasingly are unwilling to spend quality time in
galleries learning about artists and their work: after
all, why bother? The art content of these containers
and markets should thus avoid being excessively
arcane and hard to grasp, love, and own; and to
store or lend. Many can literally be carried out under
a collector's arm. The work should be painting, if
possible, for so many reasons, ranging from the
symbolic artisanal value of the handmade to the

continuity with traditional art historical discourse and the avoidance of overly particularistic political partisanship except if highly idiosyncratic or expressionist. The look of solemnity will trump depth and incisive commentary every time; this goes for any form, including museum-friendly video installations, film, animation, computer installations, and salable performance props (and conceptualism-lite). Young artists (read: recent art-school graduates) are a powerful attraction for buyers banking on rising prices.

The self-described Resistanbul Commissariat writes of "the popularity of politically engaged art within the museums and markets"—well, perhaps. The art world core of cognoscenti who validate work on the basis of criteria that set it apart from a broad audience may favor art with a critical edge, though not perhaps for the very best reasons. Work engaged with real-world issues or exhibiting other forms of criticality may offer a certain satisfaction and flatters the viewer, provided it does not too baldly implicate the class or subject position of the viewer. Criticality can take many forms, including highly abstract ones (what I have called "critique in general," which often, by implicating large swathes of the world or of humankind, tends to let everyone off the hook), and can execute many artful dodges. Art history's genealogical dimension often leads to the acceptance of "politico-critical" work from past eras, and even of some contemporary work descended from this, which cannot help but underscore its exchange value. Simply put, to some connoisseurs and collectors, and possibly one or two museum collections, criticality is a stringently attractive brand. Advising collectors or museums to acquire critical work can have a certain sadistic attraction, directed both toward the artist and the

Take the Money and Run? Can Political and
Socio-Critical Art "Survive"?

Martha Rosler

work and toward the advisee/collector.

A final common feature of this new global art is a readily graspable multiculturalism that creates a sort of United Nations of global voices on the menu of art production. Multiculturalism, born as an effort to bring *difference* out of the negative column into the positive with regard to qualities of citizens, long ago became also a bureaucratic tool for social control, attempting to render difference cosmetic. Difference was long ago pegged as a marketing tool in constructing taste classes; in a business book of the 1980s on global taste, the apparently universal desire for jeans and pizza (and later, Mexican food) was the signal example: the marketable is different but not *too* different. In this context, there is indeed a certain bias toward global corporate internationalism—that is, neoliberalism—but that of course has nothing to do with whether "content providers" identify as politically left, right, independent, or not at all. Political opinions, when they are manifested, can become mannerist tropes.

But often the function of biennials and contemporary art is also to make a geopolitical situation visible to the audience, which means that art continues to have a mapping and even critical function in regard to geopolitical realities. Artists have the capacity to condense, anatomize, and represent symbolically complex social and historical processes. In the context of internationalism, this is perhaps where political or critical art may have its best chance of being seen and actually understood, for the critique embodied in a work is not necessarily a critique of the actual locale in which one stands (if it describes a specific site, it may be a site "elsewhere"). Here I ought provisionally to suspend my criticism of "critique in general." I am additionally willing to suspend my critique of work that

might be classed under the rubric "long ago or far away," which in such a context may also have useful educational and historical functions—never forgetting, nonetheless, the vulnerability to charges such as those made by the Resistanbul group.

"Down with critical studies," I wrote above, and the present has indeed been seen as a post-critical moment, as any market-driven moment must be ... but criticality seems to be a modern phoenix: even before the market froze over, there had never been a greater demand on the part of young art students for an entrée into critical studies and concomitantly for an understanding of predecessors and traditions of critical and agitational work. I speculate that this is because they are chafing under the command to succeed, on market terms, and therefore to quit experimenting for the sake of pleasure or indefinable aims. Young people, as the hoary cliché has it, often have idealistic responses to received orthodoxy about humanity and wish to repair the world, while some artists too have direct experience of poverty and social negativity and may wish to elevate others—a matter of social justice. Young artists perennially reinvent the idea of collaborative projects, which are the norm in the rest of the world of work and community and only artificially discouraged, for the sake of artistic entrepreneurism and "signature control," in the art-market world.[42]

I return to the question posed above, "whether choosing to be an artist means aspiring to serve the rich ..." Time was when art school admonished students not to think this way, but how long can the success academy hang on while galleries are not to be had? (Perhaps the answer is that scarcity only increases desperation; the great pyramid of struggling artists underpinning the few

at the pinnacle simply broadens at the base.) Nevertheless, artists are stubborn. The "Resistanbul" writers tell us they "resist in the streets not in corporate spaces reserved for tolerated institutional critique," as some artists do in order to "help them clear their conscience." For sure. There are always artworks, or art "actions," that are situated outside the art world or that "cross-list" themselves in and outside the golden ghettos. I am still not persuaded that we need to choose. There is so far no end to art that adopts a critical stance—although perhaps not always in the market and success machine itself, where it is always in danger of being seriously rewritten, often in a process that *just takes time.* It is this gap between the work's production and its absorption and neutralization that allows for its proper reading and ability to speak to present conditions.[43] It is not the market alone, after all, with its hordes of hucksters and advisers, and bitter critics, that determines meaning and resonance: there is also the community of artists and the potential counterpublics they implicate.

This essay began as a talk at the Shanghai Contemporary Art Fair in September of 2009, on the symposium's assigned topic, "What Is Contemporary Art?"—a perfectly impossible question, in my opinion (although I could imagine beginning, perhaps, by asking, "What makes contemporary art contemporary?"). Nevertheless, talk I did. My efforts in converting that talk, developed for a non-U.S. audience, with unknown understandings of my art world, into the present essay have led me to produce what strikes me as a work written by a committee of one—me—writing at various times and for various readers. I long ago decided to take to heart Brecht's ego-puncturing suggestion—to recruit my own writing in the service of talking with other audiences, entering other universes of discourses, to cannibalize it if need be.

There are lines of argument in this essay that I have made use of at earlier conferences (one of which lent it the title "Take the Money and Run"), and there are other self-

quotations or paraphrases. I also found myself reformulating some things I have written before, returning to the lineage and development of artistic autonomy, commitment, alienation, and resistance, and to the shape and conditions of artistic reception and education.

I thank Alan Gilbert, Stephen Squibb, and Stephen Wright for their excellent readerly help and insights as I tried to impose clarity, coherence, and some degree of historical adequacy on the work.

1

To belabor the point: if medieval viewers read the symbolic meaning of a painted lily in a work with a Biblical theme, it was because iconographic codes were constantly relayed, while religious stories were relatively few. In certain late-nineteenth-century English or French genre paintings, as social histories of the period recount, a disheveled-looking peasant girl with flowing locks and a jug from which water pours unchecked would be widely understood to signify the sexual profligacy and availability of attractive female Others. Art has meanwhile freed itself from the specifics of stories (especially of history painting), becoming more and more abstract and formal in its emphases and thus finally able to appeal to a different universality: not that of the universal Church but of an equally imaginary universal culture (ultimately bourgeois culture, but not in its mass forms) and philosophy.

2

I am confining my attention to Western art history. It is helpful to remember that the relatively young discipline of art history was developed as an aid to connoisseurship and collection and thus can be seen as *au fond* a system of authentication.

3

By this I do not intend to ignore the many complicating factors, among them the incommensurability of texts and images, nor to assert that art, in producing images to illustrate and interpret prescribed narratives, can remotely be considered to have followed a clear-cut doctrinal line without interposing idiosyncratic, critical, subversive, or partisan messages, but the gaps between ideas, interpretations,

and execution do not constitute a nameable trend.

4

What has come to be known as the "middle class" (or classes), if this needs clarification, comprised those whose livelihoods derived from ownership of businesses and industries; they were situated in the class structure between the landed aristocracy which was losing political power, and the peasants, artisans, and newly developing urban working class.

5

French sociologist Pierre Bourdieu is the most prominent theorist of symbolic capital and the production and circulation of symbolic goods; I am looking at "The Market of Symbolic Goods," in *The Field of Cultural Production*, ed. Randal Johnson (New York: Columbia University Press, 1993). This article, a bit fixed in its categories, sketches out the structural logic of separation.

6

The first application of the term to art is contested, some dating it as late as the Salon des Refusés of 1863.

7

Forms, rather than being empty shapes, carry centuries of Platonic baggage, most clearly seen in architecture; formal innovation in twentieth-century high modernism, based on both Kant and Hegel, was interpreted as a search for another human dimension.

8

In his *Biographia Literaria* (1817), the poet and theorist Samuel Taylor Coleridge famously distinguished between Fancy and Imagination.

9
John Fekete, *The Critical Twilight: Explorations in the Ideology of Anglo-American Literary Theory from Eliot to McLuhan* (New York: Routledge & Keegan Paul, 1977). Especially in Europe but also in the United States, financial panics, proletarian organizing, and political unrest characterized the latter half of the nineteenth century.

10
Modernism in the other arts has a similar trajectory without, perhaps, the direct legacy or influence of Sovietism or workers' movements.

11
The codification of social observation in the nineteenth century that included the birth of sociology and anthropology also spurred as-yet amateur efforts to record social difference and eventually to document social inequality. Before the development of the Leica, which uses movie film, other small, portable cameras included the Ermanox, which had a large lens but required small glass plates for its negatives; it was used, for example, by the muckraking lawyer Erich Salomon.

12
For example with regard to the blurred line between photography and commercial applications, from home photos to photojournalism (photography for hire), a practice too close to us in time to allow for a reasoned comparison with the long, indeed ancient, history of commissioned paintings and sculptures.

13
There is generally some tiny space allotted to one or two documentarians, above all for those addressing dire conditions in the global periphery.

14
Modernist linguistic experiments are beyond my scope here.

15
This is to overlook the role of that major part of the intellectual class directly engaged in formulating the ideological messages of ruling elites. For one historical perspective on the never-ending debate over the role of intellectuals vis-à-vis class and culture, not to mention the nation-state, see Julien Benda's 1927 book *La Trahison des Clercs* (*The Betrayal of the Intellectuals*; literally: "The Treason of the Learned"), once widely read but now almost quaint.

16
See Peter Bürger, *Theory of the Avant-Garde* (1974), trans. Michael Shaw (Minneapolis: University of Minnesota Press, 1984), a work that has greatly influenced other critics—in the United States, notably Benjamin Buchloh. On Bürger's thesis, I wrote, in "Video: Shedding the Utopian Moment" (1984), that he had described the activity of the avant-garde as the self-criticism of art as an institution, turning against both "the distribution apparatus on which the work of art depends and the status of art in bourgeois society as defined by the concept of autonomy." I further quoted Bürger: "the intention of the avant-gardists may be defined as the attempt to direct toward the practical the aesthetic experience (which rebels against the praxis of life) that Aestheticism developed. What most strongly conflicts with the means-end rationality of bourgeois society is to become life's organizing principle."

17
Ibid., 53.

18
Ibid., 53–54.

19
Allan Kaprow, "The Education of the Un-Artist, Part I," *Art News*, February 1971; "The Education of the Un-Artist, Part II," *Art News*, May 1972; "The Education of the Un-Artist, Part III," *Art in America*, January 1974.

20
Nevertheless, in pop-related subcultures, from punk to heavy metal to their offshoots in skateboard culture, authenticity is a dimension with great meaning, a necessary demand of any tight-knit group.

21
Debord was also a member, with Isidore Isou, of the Lettrists, which he similarly abandoned.

22
Thus the insistence of some university art departments that they were fine arts departments and did not wish to offer, say, graphic arts or other commercial programs and courses (a battle generally lost).

23
Again channeling Althusser.

24
The "culture wars" are embedded in a broader attempt to delegitimize and demonize social identities, mores, and behaviors whose public expression was associated with the social movements of the 1960s, especially in relation to questions of difference.

25
This is not the place to argue the importance of the new social movements of the 1960s and beyond, beyond my passing attention to feminism, above; rather, here I am simply pointing to the ability of art institutions and the market to strip work of its resonance. As is easily observable, the term "political art" is reserved for work that is seen to dwell on analysis or critique of the state, wage labor, economic relations, and so on, with relations to sexuality and sex work always excepted.

26
Recall my earlier remarks about both the academicization of art education and the function of art history, a function now also parceled out to art reviewing/criticism.

27
A favorite slogan of the period was "There is no outside." Another, more popularly recognizable slogan might be "Think different," a slogan that attempts to harness images of powerful leaders of social movements or "pioneers" of scientific revolutions for the service of commodity branding, thus suggesting motion "outside the box" while attempting never to leave it. See the above remarks on Bürger and the theory of the avant-garde.

28
See Brian Holmes, "The Flexible Personality: For a New Cultural Critique" (2001), http://theadventure.be/node/253, or at http://www.16beavergroup.org/pdf/fp.pdf, and numerous other sites; Holmes added a brief forward to its publication at eipcp (european institute for progressive cultural policies), http://transform.eipcp.net/transversal/1106/holmes/en#redir.

29
Bill Readings, The University in Ruins (Cambridge, Mass.: Harvard University Press, 1997). The relative invisibility of Readings' book seems traceable to his sudden death just before the book was released, making him unavailable for book tours and comment.

30
David Harvey, "University, Inc.," review of The University in Ruins, by Bill Readings," The Atlantic (October 1998). Available online at http://www.theatlantic.com/issues/98oct/ruins.htm. Nothing could be more indicative of the post-Fordist conditions of intellectual labor and the readying of workers for the knowledge industry than the struggle over the U.S.' premier public university, the University of California system, the birthplace of the "multiversity" as envisioned by Clark Kerr in the development of the UC Master Plan at the start of the 1960s. State public universities, it should be recalled, were instituted to produce homegrown professional elites; but remarkably enough, as the bellwether California system was undergoing covert and overt privatization and being squeezed mightily by the state government's near insolvency, the system's president blithely opined that higher education is a twentieth-century issue, whereas people today are more interested in health care, and humorously likened the university to a cemetery (Deborah Solomon, "Big Man on Campus: Questions for Mark Yudoff, New York Times Magazine, September 24, 2009, http://www.nytimes.com/2009/09/27/magazine/27fob-q4-t.html?ref=magazine). The plan for the California system seems to be to reduce the number of California residents attending in favor of out-of-staters and international students, whose tuition costs are much higher. For further comparison, it seems that California

now spends more than any other state on incarceration but is forty-eighth in its expenditure on education.

31
Readings, The University in Ruins, 50.

32
Paulo Virno, A Grammar of the Multitude: For an Analysis of Contemporary Forms of Life, trans. Isabella Bertoletti, James Cascaito, and Andrea Casson (Cambridge, Mass.: Semiotext(e), 2003), also available online at http://www.generation-online.org/c/fcmultitude3.htm. I have imported this discussion of Virno's work from an online essay of mine on left-leaning political blogs in the United States.

33
Ibid., 66-67.

34
See Benedict Anderson, Imagined Communities: Reflections on the Origin and Spread of Nationalism (New York: Verso, 1983).

35
Here I will not take up the question of museums' curatorial responses to this moment of crisis in respect to their definition and role in the twenty-first century. I can only observe that some elite museums have apparently identified a need to offer a more high-end set of experiences, in order to set them apart from the rest of our burgeoning, highly corporatized "experience economy." At present the main thrust of that effort to regain primacy seems to center on the elevation of the most under-commodified form, performance art, the form best positioned to provide museum-goers with embodied and nonnarrative experiences (and so far decidedly removed from the world of the everyday or of "politics" but situated firmly in the realm of the aesthetic).

36
Since writing this, I have read Chin-Tao Wu's "Biennials Without Borders?"—in New Left Review 57 (May/Jun 2009): 107–115—which has excellent graphs and analyses supporting similar points. Wu analyzes the particular pattern of selection of artists from countries on the global "peripheries."

37
The 11th Istanbul Biennial ran from September through November, 2009, under the curatorship of a Zagreb-based collective known as What, How, and for Whom (WHW), whose members are Ivet Ćurlin, Ana Dević, Nataša Ilić, and Sabina Sabolović. Formed in 1999, the group has run the city-owned Gallery Nova since 2003. The title of this biennial, drawn from a song by Bertolt Brecht, is "What Keeps Mankind Alive?"

38
The full version of the letter can be found online at http://etcistanbul.word-press.com/2009/09/02/open-letter/.

39
Important sites of concerted public demonstrations against neoliberal economic organizations and internationally sanctioned state domination and repression.

40
But they may well be offered flyers.

41
The Shanghai Contemporary Art Fair (where this paper was first presented) is an outpost of the Bologna Art Fair.

42
I experience some disquiet in the realization that, as in so much else, the return of the collective has lingering over it not just the workers' councils of council communism (not to mention Freud's primal horde) but the quality circles of Toyota's re-engineering of car production in the 1970s.

43
It is wise not to settle back into the image-symbolic realm; street actions and public engagement are basic requirements of contemporary citizenship. If the interval between the appearance of new forms of resistance and incorporation is growing ever shorter, so is the cycle of invention, and the pool of people involved is manifestly much, much larger.

Hal Foster

Contemporary Extracts

On this occasion I will simply quote from several of the responses I received to a questionnaire—subsequently published in *October* magazine—about "contemporary art." First, my questions:

The category of "contemporary art" is not a new one. What is new is the sense that, in its very heterogeneity, much present practice seems to float free of historical determination, conceptual definition, and critical judgment. Such paradigms as "the neo-avant-garde" and "postmodernism," which once oriented some art and theory, have run into the sand, and, arguably, no models of much explanatory reach or intellectual force have risen in their stead. At the same time, perhaps paradoxically, "contemporary art" has become an institutional object in its own right: in the academic world there are professorships and programs, and in the museum world departments and institutions, all devoted to the subject, and most tend to treat it as apart not only from prewar practice but from most postwar practice as well.

 Is this floating-free real or imagined? A merely local perception? A simple effect of the end-of-grand-narratives? If it is real, how can we specify some of its principal causes, that is, beyond general reference to "the market" and "globalization"? Or is it indeed a direct outcome of a neoliberal economy, one that, moreover, is now in crisis? What are some of its salient consequences for artists, critics, curators, and historians—for their formation and their practice alike? Are there collateral effects in other fields of art history? Are there instructive analogies to be drawn from the situation in other arts and disciplines? Finally, are there benefits to this apparent lightness of being?[1]

As you can see, the questions are directed at critics and curators based in North America and Western Europe; I hope they do not appear too provincial as a result. I have arranged the extracts with an eye to connections that exist between them. My purpose here is simply to suggest the state of the debate on "the contemporary" in my part of the world today.

First from Grant Kester, a historian of contemporary art, based in southern California:

> The problem of "the contemporary" is rooted in a tension that emerged when Western art history was first formalized as a discipline. The generation of European historians that helped establish the discipline in the mid-nineteenth century found itself confronted by a vast range of new and unfamiliar artifacts that were circulating throughout Europe as a result of colonial expansion into Africa, Asia, and the Americas, as well as early archaeological excavations in Italy and Greece. Historians and philosophers raised the question of how contemporary viewers could transcend the differences that existed between themselves and very different cultures whose works of art they admired—cultures whose shared meanings were inaccessible to them due to distances of time or space.

Then from James Elkins, a meta-theorist of art history, based in Chicago:

> From the perspectives of "world art history" and its critics today, "the contemporary" would appear to be either exempted from the discipline of art history, because of its position outside or before art histories, or exemplary of the

discipline, because of its newfound universality (i.e., by definition "the contemporary" exists everywhere).

Next from Miwon Kwon, a contemporary art critic and historian based in Los Angeles:

Contemporary art history sits at a crossroads in the uneven organization of the subfields that comprise the discipline of art history. Within most university art history departments, one group of subfields covering Western developments is organized chronologically, as periods (i.e., from Ancient to Modern, with Medieval and Renaissance in between). Another group of subfields that covers non-Western developments is identified geographically, as culturally discrete units even if they encompass an entire continent (i.e., African, Chinese, Latin American, etc.) The category of contemporary art history, while institutionally situated as coming *after* the Modern, following the temporal axis of Western art history as the most recent period (starting in 1945 or 1960 depending on how a department divides up faculty workload or intellectual territory), is also the space in which the contemporaneity of histories from around the world must be confronted simultaneously as a disjunctive yet continuous intellectual horizon, integral to the understanding of the present (as a whole). Contemporary art history, in other words, marks both a temporal bracketing and a spatial encompassing, a site of a deep tension between very different formations of knowledge and traditions, and thus a challenging pressure point for the field of art history in general.

For instance, what is the status of contemporary Chinese art history? What is the time frame for such a history? How closely should it be linked to Chinese art, cultural, or political history? How coordinated should it be with Western art history or aesthetic discourse? Is contemporary Chinese art history a subfield of contemporary art history? Or are they comparable categories, with the presumption that the unnamed territory of contemporary art history is Western/American?

Then from Joshua Shannon, a historian of postwar art, from the mid-Atlantic area near Washington, D.C.:

In the last twenty-five years, the academic study of contemporary art has grown from a fringe of art history to the fastest-developing field in the discipline. It is not so long ago that dissertations on living artists were all but prohibited, while statistics published this year by the College Art Association confirm that job searches in contemporary art history now outnumber those in any other specialization, with almost twice as many positions in the field, for example, as in Renaissance and Baroque combined. We might wonder whether a discipline too long afraid of the present has now become besotted with it.

Next from Richard Meyer, a theorist of "the contemporary," based in Los Angeles:

Recently, I have put to my "contemporary" students several questions that are at once straightforward and aggressive. Why are you studying art history if what you really want is to write about the current moment? Where are the archival and

research materials on which you will draw—in the files of a commercial gallery, in a drawer in the artist's studio, in the works of art themselves, in a series of interviews that you intend to conduct with the artist, in a theoretical paradigm that you plan to apply to the work, or in an ideological critique of the current moment? What distinguishes your practice as a contemporary art historian from that of an art critic? And how does the history of art matter to the works you plan to write about and to the scholarly contribution you hope to make?

Then from Pamela Lee, a scholar on postwar art, based in San Francisco:

Call it "the moving target syndrome." At what point does a stack of press releases turn into something like a proper reception history? How do you write about a contemporary artist whose work shifts radically in mid-stream? And what does one do when the topics that seemed so pressing and so critical just a few short art-world seasons back lose that sense of urgency? There is, then, a paradoxical way we might characterize the problem: contemporary art history is premature because it is always in a perpetual state of becoming, one that alternates endlessly between novelty and critical (as well as commercial) exhaustion.

Next from Mark Godfrey, a young curator of contemporary art at Tate Modern in London:

If it is correct that no "paradigms" have emerged in the place of those such as "the neo-avant-garde" and "postmodernism," then one should

first look precisely to the success of those discourses to understand why. The critical discourse of postmodernism caused most historians and critics to distrust any overarching and monolithic model that would account for what is most compelling about contemporary art. At the same time, following the impact of postcolonial theory and a simple widening of our horizons, American and European art historians and curators have become far more attentive to contemporary art as it emerges across the world. Most acknowledge that serious art is being made in China, Latin America, South Africa, and so on, but few have the opportunities to see what is being made. With this situation, who would presume to name a new paradigm? A new name would assume a totalizing explanatory power and be akin to a hubristic, neocolonial move. One also begins to distrust the presumptions of the previous paradigms. How useful are the terms "neo-avant-garde" or "postmodernism" when we think about the art that emerged in centers away from North America and Western Europe where modernism and the avant-garde signified quite differently?

Then from Terry Smith, an Australian art historian with special expertise on the contemporary, based in Pittsburgh:

How has the current world-picture changed since the aftermath of the Second World War led to the reconstruction of an idea of Europe, since decolonization opened up Africa and Asia, with China and India emerging to superpower status but others cycling downwards, since the era of revolution versus dictatorship in South America led first to the imposition of neoliberal

economic regimes and then to a continent-wide swing towards populist socialism? As the system built on First-, Second-, Third-, and Fourth-world divisions imploded, what new arrangements of power came into being? Now that the post-1989 juggernaut of one hyperpower, unchecked neoliberalism, historical self-realization, and the global distribution of ever-expanding production and consumption tips over the precipice, what lies in the abyss it has created? Above all, how do we, in these circumstances, connect the dots between world-picturing and place-making, the two essential parameters of our being?

Next from Alex Alberro, a Canadian historian of postwar art, based in New York:

The contemporary is witnessing the emergence of a new technological imaginary following upon the unexpected and unregulated global expansion of the new communication and information technologies of the Internet. For one thing, technological art objects have increasingly come to replace tangible ones in art galleries and museums, which have seen an upsurge in high-tech hybrids of all kinds, from digital photography, to film and video installations, to computer and other new-media art. The "white cube" has begun to be replaced by the "black box," and the small-screen film or video monitor by the large-scale wall projection. For another thing, the image has come to replace the object as the central concern of artistic production and analysis. In the academy, the rise of visual studies in this period is symptomatic of the new preeminence of the image. Furthermore, the imaginary of this shift from analog to digital has had a number of

unpredictable effects. One of the most striking of these is the proliferation of artworks that employ fiction and animation to narrate facts, as if to say that today the real must be fictionalized in order to be thought, that the real is so mind-boggling that it is easier to comprehend by analogy.

Then from Tim Griffin, editor-in-chief of *Artforum*, based in New York:

The potential irony of contemporary art is that by signaling its stand apart, this art actually articulates itself as another niche within the broader cultural context—as just one more interest among so many others. Such a development is paradoxical in its implications. It becomes increasingly important for art to assert its own distinctiveness in order to exist—often by reinscribing itself within its various histories, projecting previous eras' interpretive models onto present circumstances—at the same time that such an assertion makes art resemble current mass culture all the more.

Next from Yates McKee, a young activist/critic based in the Midwest:

The multiple institutionalizations of contemporary art entail new modes of affiliation, possibility, and complicity for artistic and critical activity. Without disavowing the urgency of macro-systemic analysis, assessing these entanglements is a matter of close, site-specific reading rather than blanket celebration or denunciation. This means refusing to reduce contemporary art to a flavor-of-the-month novelty either as peddled by art-market boosters,

on the one hand, or as preemptively dismissed by guardians of art-historical authority on the basis of melancholic—and often hypocritically self-exculpating—narratives of "the cultural logic of late capitalism," on the other. Following the example of curator and critic Okwui Enwezor, the increasingly transnational scope of contemporary art in discursive, institutional, and economic terms needs to be recognized as a productive intellectual challenge to entrenched artistic, critical, and historical traditions, requiring the latter two to engage artistic practice in light of the ongoing contradictions of what Enwezor has called the "postcolonial constellation."

Then from T. J. Demos, a historian of contemporary art, based in London:

One risk is to fall victim to the ultimately patronizing multicultural "respect" for difference that disavows any criticality whatsoever. The latter potentially disguises a neocolonial relation to the Other, as Slavoj Žižek argues, for whom multiculturalism may disclose "a disavowed, inverted, self-referential form of racism, a 'racism with a distance'—it 'respects' the Other's identity, conceiving the Other as a self-enclosed 'authentic' community towards which he, the multiculturalist, maintains a distance rendered possible by his privileged universal position."[2]

Next from Kelly Baum, a young curator of contemporary art at my home institution, Princeton University:

What if art's heterogeneity signals possibility instead of dysfunction? What if heterogeneity is art's pursuit instead of its affliction? What if, in

its very heterogeneity, art were to productively engage current socio-political conditions— conditions that are reducible to neither neo-liberalism nor globalization?

I think what we are seeing today is art miming its context. I think we are witnessing art performing "agonism," "disaggregation," and "particularization." Heterogeneity isn't just contemporary art's condition, in other words; it is its subject as well.

Finally from Rachel Haidu, a young historian of post-war art, based in upstate New York:

Why—other than for the narcissistic pleasures related to knowing—do we want a relationship to history? Your questions frame the relevance of history to our critical relationships to art, but what about those desires, fantasies, and displacements of which criticism is made? Certainly they are wedged into our criticism of art's relation to history. When art forces us to examine them in specific and productive ways, we are lucky: otherwise, what is the point of asking art (let alone the institutionalization of art) to find historical complexity or weight? For the sake of weight alone? To reassure us of our relations to a history without which we would feel . . . guilty? Irrelevant?

1
Hal Foster for the Editors, "Questionnaire on 'The Contemporary,'" *October* 130 (Fall 2009): 3.

2
Slavoj Žižek, "Multiculturalism, Or, the Cultural Logic of Multinational Capitalism," *New Left Review* 225 (Sept/Oct 1997): 44.

What Is Contemporary Art?

Zdenka Badovinac

Contemporaneity as Points of Connection

When the editors of *e-flux journal* invited me to write about contemporaneity, they suggested that I take my own professional experience as a starting point. And it seems that, in order to understand contemporaneity, we cannot neglect the particularity of various approaches. Contemporary theory, however, and especially Badiouan theory, teaches that this can lead us astray and we should rather devote ourselves to thinking about a new understanding of universality. For this reason, I have tried to place my own particular story—which is linked to the broader context of Eastern Europe and, more narrowly, to my work at the Moderna galerija in Ljubljana—in connection with other, related experiences, especially those linked to the issues surrounding the Global South. One might even suggest that sharing various points of connection is, in fact, one of the key concepts of contemporaneity.

1. Narratives in the Plural

If we can no longer speak of the evolution of art over the course of history, we can certainly speak about the evolution of its accessibility. Accessibility to art increased exponentially in the twentieth century, primarily through the power of reproduction and the work of museums open to the general public. The democratization of art is, certainly, one of the important aspirations of modernity, although in many ways this is still limited to educating from above and the selective standards that entails. But today this enlightenment model is already being threatened by knowledge penetrating from below. I am speaking especially about current processes that oppose the various hegemonic models created by Western modernity. In this essay, I use the word "contemporaneity" as an alternative concept to

modernity—a term which I do not connect with any specific time period.

"'Modernity' is not a historical period but a discursive rhetoric, that is, a persuasive discourse promising progress, civilization and happiness."[1] This is how Walter Mignolo describes modernity, especially with regard to its darker side, which he calls "coloniality." For theorists of decoloniality, "coloniality" is something that still persists today, and in opposition to the processes of decolonization.[2] The distinguishing features of coloniality, which link the issues surrounding the Global South, may also apply, at least in part, to Eastern Europe. Despite the fact that socialism was itself a unique project of modernity with its own globalization project, its own colonialism, and its own (pop) culture and art, the socialist countries, like other parts of the world, were hardly immune to Westernizing processes.

If attitudes in both East and West influenced each other mutually during the Cold War, then today the various interminglings of their processes can only testify to a further accelerated global dimension. To many, therefore, it seems that "planetary negotiations, discussions between agents from different cultures" are today taking place unhindered.[3] For this reason, too, it is becoming increasingly important to ask how great a share a given space really inhabits in the global exchange of ideas, and to what degree this exchange reflects the polarization of the world into Global North and Global South.

When we think about contemporaneity, then, we must by no means overlook the question of participation, both in global exchanges and in particular spheres of life. Irit Rogoff describes contemporaneity as a sense of participation in discussions about unstructured forms of knowledge:

"Contemporaneity" is our subject—not as a historical period, not as an explicit body of materials, not as a mode of proximity or relevance to the subjects we are talking about, but rather as a conjunction. "Contemporaneity" for us means that in the contemporary moment there is a certain number of shared issues and urgencies, a certain critical currency, but perhaps most importantly a performative enablement—a loosening of frames all around us, which means we can move around more freely, employ and deploy a range of theoretical, methodological and performative rhetoric and modes of operation, inhabit terrains that may not have previously made us welcome or, more importantly, which we would not have known how to inhabit productively.[4]

Although Rogoff is speaking here primarily about the interlacing territories of various fields of knowledge that are connected by a shared sense of urgency with regard to certain common questions, we could apply a similar model to the exchange of knowledge between various geopolitical territories. Access to different kinds of knowledge through various points of connection as well as the possibility of participating in common debates may be counted as part of the same set of concerns that characterize concepts of decolonization. Issues of access and participation in various processes of knowledge are also shaping, to an increasing degree, the basic features that define the imaginary of contemporary art.

In "Who's Afraid of the Neo-Avant-Garde?" Hal Foster discusses the need to create a new narrative that, following the psychoanalytical model, would treat neo-avant-garde art concepts in terms of their repeating the unfinished work of the artistic revolutions of the early twentieth century. Foster writes:

The status of Duchamp as well as *Les Demoiselles* is a retroactive effect of countless artistic responses and critical readings, and so it goes across the dialogical space-time of avant-garde practice and institutional reception.[5]

The mature art system and its market contributed crucially to the fact that a given artwork could become part of history through countless cycles of repetition. Regardless of how we define the repetitions of the historic avant-garde vis-à-vis those of the neo-avant-garde—merely as farce or as the full, if deferred, realization of the avant-garde's potential—the story remains embedded in the logic of that same art system. The hegemonic art system, with its museums, theory, and market, makes possible the repetition of artistic concepts over various historical periods.

But that which the system assimilates must conform to its standards. If, as Foster writes, the institution of art was something the artists of the historic avant-garde wished only to do away with, and something that was in fact analyzed by the neo-avant-gardists, then it must be made clear that this applies above all to the Western space. Even if, for instance, the Russian avant-gardists wanted to burn down everything old, including the bourgeois institutions, we do not see in the works of their heirs in the East any kind of repetition in the sense of an institutional critique, at least not to the same degree as we have in the West. For the Eastern neo-avant-garde movements, the primary target of their attack was ideology and not the art system, which even today has, for all practical purposes, not yet developed in the East in any form comparable to that of the West. So when we speak of a new narrative that would be more suitable to the present and

to the global situation, we can only speak of narratives in the plural.

While the concept of the plurality of narratives can be connected with the idea of the unfinished nature of the historic avant-gardes, it should, however, be linked first and foremost to the unfinished project of decoloniality. The production of local bodies of knowledge, which include the genealogies of local avant-gardes, is a precondition for establishing any "planetary negotiations" on an equal basis. We could relate such thinking to the notion of "transmodernity" put forward by the proponents of decolonialist theory.[6] The decolonialists oppose the concept of transmodernity to the Western concepts of postmodernity and altermodernity, as well as to such notions as alternative modernities, subaltern modernities, and peripheral modernities. In Mignolo's view, all these concepts still maintain "the centrality of Euro-American modernity or, if you wish, assume one 'modernity of reference' and put themselves in subordinate positions."[7]

We would be very mistaken if we in any way supposed that emancipatory ideas come only from the non-Western world. This would be like saying that socialism was solely the project of the East. Susan Buck-Morss has nicely stated that this was not the case: "The historical experiment of socialism was so deeply rooted in the Western modernizing tradition that its defeat cannot but place the whole Western narrative into question."[8]

No single place can claim exclusive rights to emancipatory knowledge, which is important to the entire planet. It is true, however, that certain spaces have more potential to instrumentalize knowledge than others. Those that are in a better position in this regard also, therefore, contribute

Zdenka Badovinac

more to the positive or negative development of global society. Spaces with a weaker infrastructure, which might otherwise serve the ongoing structuring and distribution of local knowledge, are here in a disadvantaged position. The most these spaces can do is seek connections with other, similar conditions in the struggle for greater participation in the global exchange. That something of this sort is already happening can be seen in the congruity between various theoretical concepts, such as the notion of pluri-versality that Mignolo describes: "Pluri-versality requires ... *connectors*, connectors among projects ... moving, advancing, unfolding in the same direction (departing from the colonial matrix of power), but following singular paths emerging from *local histories*."[9]

2. Self-Definition

In my day-to-day work, much of what I do involves questions around defining contemporaneity within the field of art, with regard to both artistic practices and the spaces where art is presented. Over the past twenty years I have constantly been forced to consider these questions by, among other things, the specific nature of the Slovene space, which at the beginning of my professional career in the second half of the 1980s, was entirely dominated by representatives of the modernist orthodoxy. In addition, the specific needs of the Moderna galerija in Ljubljana, where I have served as director for over a decade and a half, have also led me to a more intensive examination of the issues surrounding contemporaneity. This institution's various acute needs have culminated today in the idea of a museum of contemporary art, which will become a reality, we expect, in a little more than eighteen months. In the remainder of this text, if I

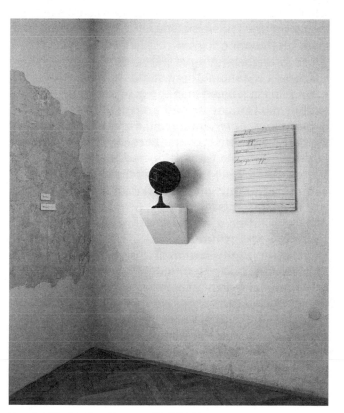

Mangelos, *Manifest About Energy, no. 000,* 1977–78.

discuss my own experiences in this country of two million people, it is only because I believe they are, in a way, symptomatic—an example of the praxis of what are called "peripheral spaces" and an illustration of all that I have presented above on a more general, theoretical level.

At the beginning of the 1990s, when I became the director of the Moderna galerija, I found myself in a situation where I had to adopt a clear and unequivocal stance on many different issues—not only because of the importance of the position I had assumed, but also because of the particular nature of the moment we were living in. With the collapse of Yugoslavia, the Moderna galerija had become the central art institution of a new country, whose birth had been accompanied by a ten-day war, a war that had then shifted to the rest of the Balkans, where it continued for the next several years. The proximity of war, the old/new nationalisms, the blurring of the progressive ideas of communism and the equating of communism with fascism, the increasing emulation of the West, and the beginnings of a new liberal economy—all of this helped to create the spirit of the time, which was already so different from that of the late eighties, when I had started working at the Moderna galerija.

Along with my colleagues, especially Igor Zabel, with whom I had worked for many years, I asked myself how a museum can move forward in its work when it has been primarily dedicated to a national art—an art that, as even the most ambitious studies took pains to stress, lagged eternally behind Western art. The prevailing criticism and theory would, sometimes quite crudely, place our art in the "universal" Western context and blithely neglect anything that was associated with our own avant-garde traditions and the very powerful

processes of self-contextualization that had been happening in artistic practices in Slovenia, particularly throughout the 1980s. And I am not even speaking here of the near-total absence of a critical theory that could place these relations in broader political and social contexts—a critical theory of which even today we find no trace, at least in the way art history is taught. A great lack of self-confidence, which at times borders on servility toward the West, exists not only in Slovenia but in all the so-called peripheral spaces; this was, and still is, responsible for everything we might designate, at least conditionally, as coloniality. How do we remedy such a situation? How do we improve our self-image?

These and similar questions encouraged us to find a different way of defining the priorities of our work. Our museum, founded in 1948 in a country which had that same year, through Tito's Cominform dispute with Stalin, taken a stand against Soviet colonialism, now began to consider a "third way": a break with the socialist tradition of national museums, a refusal to accept the "universal" Western example, and a search for a museum model that would suit its own time and space. For us, the imperative of contemporaneity became the idea that we ourselves would be the producers of our own knowledge and, as much as possible, that we would stop being the passive recipients of Western ideas. In this process we relied, right from the start, on the experiences of artists and small non-institutional spaces that had, especially in the eighties in Slovenia, developed particular strategies for self-organization, alternative networking, and operating internationally, and that were significantly more successful at doing this than the official cultural policy was. I could say, then, that in our future

operations we would use knowledge that came "from below," and in doing so, we often refused to heed the demands and expectations that came not only from the official cultural policy but also from a certain general standard of institutional behavior. Our understanding of contemporaneity was also dictated by our interest in other spaces that had till then been shut out of the artistic "universe" and with which we shared a number of similar priorities in the new historical moment. And it was our similar priorities with these spaces that saw our directives come together in new conjunctions, which we also started to understand as our principal international context.

Throughout the 1990s, then, the Moderna galerija put together a number of projects connected with the Balkans and, more generally, Eastern Europe. In 2000, we also inaugurated the first museum collection of Eastern European art, which was later followed by a series of shows we called Arteast Exhibitions. The objectives of this program were, and still are, connected above all to the idea that Eastern Europe must contextualize itself as soon as possible, that it must become the subject of its own historicization and not merely an object for the more powerful Western institutions. On the basis of my experience with these issues, I have on a number of occasions already pointed to two possible ways for Eastern European art to be musealized. The first is based on the mere inclusion of non-Western art, through its best examples, in the master narrative and in the hegemonic institutions; the second way has been to offer more possibilities for local institutions to produce knowledge about their own history, and thus indirectly influence the global art system. Of course, these two approaches are not mutually exclusive; the only question is

which of them will end up becoming dominant in the future.

When I talk about the Moderna galerija as a museum of contemporary art, however, this is not merely in the sense of the topics discussed above, but also in the very concrete sense of the actual reorganization of its work. The Moderna galerija was founded as a museum of modern art, but after more than sixty years, its official mission became too narrow and its physical space too small. Years ago, in order to solve its space problems, the Moderna galerija acquired a second building for its use, one that was in need of a total renovation. Thus the museum was forced to reorganize its activities between two separate locations. This led to the idea of a division not only between two locations but also between a museum of modern art and a museum of contemporary art, housed in two separate buildings, which in turn led to an urgent need to focus on questions around the relationship between the modern and the contemporary.

At a time when museums of modern art are increasingly becoming museums of what are now historical styles from the twentieth century, an art that has been accumulated over decades, the museum of contemporary art needs a new definition. Above all, contemporaneity needs its own museum, just as, in the early twentieth century, modern art—the art that was then contemporary to its time—needed its own museum. In a certain way, the Moderna galerija was lucky. Circumstances of various kinds have always forced us to continually define our position toward contemporaneity and thus, in a way, to defend it. From my own experience, then, I would summarize the definition of the museum of contemporary art—which is different from the museum of modern art—as follows:

If the museum of modern art served certain universal paradigms, a master narrative, and the hegemonic goals of the big Western institutions, then the museum of contemporary art must serve the needs of local spaces so that they can enter as equals into dialogues with other spaces. In order for conditions to be at all possible for designing a museum of contemporary art as I describe it here, local spaces must determine their own work priorities, which cannot be universal. The pursuit of these principal objectives is necessary if a given space is to rid itself of backwardness and provincialism and become truly timely, and not merely concurrent with the West. The museum of contemporary art must make possible the perception of art as it has developed in various contexts. And here I am thinking not only of the various artistic movements that developed within different social realities, but also of the manner of presenting art in such a space. A museum of this kind can no longer be merely a museum of art. It must also be a museum of history, a museum of a diversity of narrations and their presentation. The white cube is just one of a number of possible models for this museum. Most important here are, above all, the points of connection between the various surfaces of the cube.

Translated from the Slovene by Rawley Grau

1
Marina Gržinić and Walter Mignolo, "De-linking Epistemology from Capital and Pluri-Versality: A Conversation with Walter Mignolo, Part 3," *Reartikulacija*, no. 6 (2009), 7.

2
As Ramón Grosfoguel explains: "Peripheral nation-states and non-European people live today under the regime of 'global coloniality' imposed by the United States through the International Monetary Fund (IMF), the World Bank (WB), the Pentagon, and NATO I use the word 'colonialism' to refer to 'colonial situations' enforced by the presence of a colonial administration such as the period of classical colonialism.... I use 'coloniality' to address 'colonial situations' in the present period in which colonial administrations have almost been eradicated from the capitalist world-system. By 'colonial situations' I mean the cultural, political, sexual, and economic oppression/exploitation of subordinate racialized/ethnic groups by dominant racial/ethnic groups with or without the existence of colonial administrations." "Transmodernity, Border Thinking, and Global Coloniality: Decolonizing Political Economy and Postcolonial Studies," *Eurozine*, April 7, 2008.

3
Nicolas Bourriaud, "Altermodern Manifesto," written for the 2009 Tate Triennial (Tate Britain, London).

4
Irit Rogoff, "Academy as Potentiality," in *A.C.A.D.E.M.Y.*, ed. Angelika Nollert and Irit Rogoff (Frankfurt am Main: Revolver, 2006); available online at http://summit.kein.org/node/191. This book was published as part of an international series of exhibitions and projects initiated by the Siemens Arts Program in cooperation with the Kunstverein in Hamburg, Goldsmiths College in London, Museum van Hedendaagse Kunst Antwerp, and the Van Abbemuseum in Eindhoven.

5
Hal Foster, *The Return of the Real: The Avant-Garde and the End of the Century* (Cambridge, MA: MIT Press, 1996), 8.

6
"Transmodernity is the Latin American philosopher of liberation Enrique Dussel's utopian project to transcend the Eurocentric version of modernity Instead of a single modernity centred in Europe and imposed as a global design to the rest of the world, Dussel argues for a multiplicity of decolonial critical responses to Eurocentered modernity from the subaltern cultures and epistemic location of colonized people around the world." Grosfoguel, "Transmodernity, Border Thinking, and Global Coloniality."

7
Walter Mignolo, "Coloniality: The Darker Side of Modernity," in *Modernologies: Contemporary Artists Researching Modernity and Modernism*, ed. Sabine Breitwieser (Barcelona: Museu d'Art Contemporani de Barcelona, 2009), 42; available online at http://www.macba.cat/PDFs/walter_mignolo_modernologies_eng.pdf. As an example of "altermodernity," Mignolo cites Bourriaud's "Altermodern Manifesto" (see note 3).

8
Susan Buck-Morss, *Dreamworld and Catastrophe: The Passing of Mass Utopia in East and West* (Cambridge, MA: The MIT Press, 2002), xii.

9
Marina Gržinić and Walter Mignolo, "De-linking Epistemology from Capital and Pluri-Versality: A Conversation with Walter Mignolo, Part 2," *Reartikulacija*, no. 5 (2008), 21.

Carol Yinghua Lu

Back to Contemporary:
One Contemporary Ambition,
Many Worlds

Ai Weiwei, *Study of Perspective - Tiananmen,* 1995-2003. b/w-print, edition of 10,
90 x 127 cm. Courtesy the artist and Galerie Urs Meile, Beijing-Lucerne.

I was recently invited by the editors of *Afterall* to contribute to a book they are preparing on the monumental 1989 exhibition "Magiciens de la terre" with a text reflecting on the impact of this exhibition on the practice of Chinese artists. On that occasion I had a discussion with Chinese critic Fei Dawei, who had introduced the curator of the show, Jean-Hubert Martin, to many of the key artists of the '85 movement in China prior to the exhibition and worked as one of its regional advisors. As one of the earliest attempts to exhibit contemporary art from non-Western parts of the world in the West and to deal with the possibility of multiculturalism, this exhibition set an important precedent for many projects to come with its ambition of offering a global vision for contemporary art.

What concerned Fei and the many artists Martin encountered on his visit to China was the question of how to formulate the image of the contemporary in Chinese art. For this purpose, Fei deliberately set up studio visits for Martin to first meet with artists such as Wu Guanzhong, who worked in the modernist tradition or were part of the official art circuit in China, before leading him to meet the artists and critics of the '85 movement. At that time, both Fei and the artists consistently tried to convince Martin that contemporary art was something unfolding in the most lively manner in the country and that it represented the most current climate of artistic thinking and energy in the country—not folk art, not traditional art.

This visit left a strong impression on Martin. In the end, Chinese artists Huang Yongping, Gu Dexin, and Yang Jiechang were invited to participate in the exhibition, which also featured, for example, tribal art from Africa. It was a fortunate setup for Chinese contemporary artists—the relevance of

their practice, which had previously developed in isolation, bound to circulate only within China, was situated and viewed in an international context for the very first time. This would also have a lasting impact on how Chinese contemporary art would be represented in the many exhibitions and occasions that followed in the West.

In 2006, German art historian Hans Belting pioneered a project entitled "Global Art and the Museum" in an attempt to document the global changes in contemporary art and its institutions. Acknowledging the fact that economic globalization has—along with its own institutional practices— taken contemporary art practice beyond the restrictions of national borders, he states:

> With the new geography of auction houses, the art trade acts on a global scale, art museums, by contrast, operate within a national or urban framework in which they encounter the most diverse audiences. While art collecting has become en vogue on an unprecedented scale, it often lacks a common notion of art. Contemporary art also invades former ethnographic museums, which are forced to remap their areas of collecting. As yet, the novelty of the situation defies any safe categories.

This ongoing project, consisting of a series of panel discussions, lectures, conferences, and publications, will lead to an exhibition at the ZKM in 2011 (whose vision to present what could possibly be the global image of contemporary art today is an enormous challenge in itself). Belting, who back in 1983 proposed the end of art history and the end of art's historical narrative, has again stressed in this context that the German perspective is a local one,

and that Western art history is a time-based and culture-specific concept whose sensitivity and relevance to other periods of time and cultures should always be re-examined. A workshop he led on global art at the ZKM this past summer proposed a paradigm shift; we were reminded to no longer think about the West as the singular model to be applied worldwide, but to reflect on how to expand this model using experiences from elsewhere, or even to approach art from the perspective of a multitude of models.

As a participant in the workshop, I became more aware of my own specific local context, which is China, a country whose own position in challenging and redefining multiculturalism and global contemporality, both back in 1989 and twenty years later in 2009, has always been in question. Perhaps it's not simply a matter of creativity and what artworks are being produced, it's also a matter of perspective and methodology: how to view the works produced in this context and, more importantly, how to develop a way of working that is perceptive with regard not only to the works but also to their context, one that is closer to the works' internal complexities and constant transfigurations than to their external features and general applications.

In the following text, I would like to respond to the question "what is contemporary art?" through a historical self-reflection and by looking at the specific scenario in China through a very local perspective.

Even though China was absent from much of modernism's chronological progression, it has followed a unique track and used a set of coordinates that fuse Western and Chinese experiences. Today's Chinese artists are more than ever before deeply entrenched in an ever-evolving and gradually more

autonomous system of art production and circulation, invigorated simultaneously by the continuous inflow of international knowledge and capital, but even more so by the sheer excess of local interest, investment, and imagination.

Artists, dealers, galleries, museums, art magazines, auction houses, biennials, and art fairs are interwoven into a tighter and tighter network, eagerly replicating the mature model established in the West, while continuously and uninhibitedly adapting it to the practical and philosophical needs of specific local conditions. The unparalleled imaginativeness and potential of this local system constantly defines and redefines the method of working here.

Incidentally or not, just prior to the opening of "Magiciens de la terre" in 1989, a regrettable transition occurred in China that resounded throughout many folds of public life, fundamentally shaping the collective political, social, cultural, and psychological landscape of China with a series of disheartening closures and departures. Cultural, spiritual, and artistic aspirations became secondary to a quickly spreading and highly infectious mood of market optimism and global trade. Economic development became an effective instrument for diverting people's attention from intellectual pursuits and enlightenment. The disregard for knowledge and intellectual pursuits planted during the Cultural Revolution continued to manifest itself in a new wave of brainless entertainment. Ignorance became understood by many as a fashionable state of being.

Meanwhile, 1989 generated many drastic turns in terms of intellectual dynamics as well as personal choices. It was the year when the preceding decade of ideological opening-up and cultural enlightenment came to an abrupt and disillusioning

end. Yet the prospect of a new beginning for everyone remained irresistible, offering instant and tangible compensations and achievements. The market economy introduced a system of quantification and evaluation according to materialistic value. A pragmatic and functionalist mindset was firmly established.

A 1991 correspondence between Beijing-based art critic and curator Li Xianting and Paris-based curator Fei Dawei, both of whom were involved in the curating and organization of the "China/Avant-Garde" exhibition in February of 1989, clearly revealed their differences, not only in their geographical positions but more profoundly in their intellectual judgments and value systems. In 1991, Li Xianting wrote:

> Once art leaves its cultural motherland, it will surely die out. Exiled culture and arts have always happened in the macro cultural background in Europe. You [the artists and critics travelling abroad] represent new issues. What I want to know are opinions from every party. Although they were working against the same overall background, Warhol and Beuys each carried their respective cultural identities. Of course this is discussed on the condition that we acknowledge the new international system of value. Nationality is not the kind promoted by the government, but it does exist. We can't follow the postmodernist styles in the contemporary West using the so-called principle of modernism. In the world today, nothing can be considered avant-garde. No matter what you do, it always appears to be familiar.

At a time when international companies already spread their wings all over the world, speculating

upon and investing in a near future when they would reap the benefits of building and becoming part of a global market, some Chinese intellectuals still clung to the idea of cultural locality, in doubt of this "new international system of value." Such claims sounded extremely nationalistic and profoundly arrogant, lacking in curiosity or desire to understand the outside world. Unable to picture the West as an equal partner in cultural exchange, Li spoke about the West as both irrelevant and, at the same time, an impossible standard for the Chinese art world to emulate and be on par with. He certainly touched upon the issue of the impossibility of a contemporary avant-garde with his statement "no matter what you do, it always appears to be familiar," which remains a relevant point that constantly shakes up our decisions and judgments today.

Here I quote Li Xianting again:

> But we all cherish your activities abroad. Maybe every kind of effort has its value. We are all cornerstones and nothing (we do) would be worth international attention. Do you really believe that you yourself have had an impact on the Western art world?

In this condescending letter, Li Xianting was not only referring to Fei Dawei but to a group of Chinese artists and intellectuals who left China in the 1980s and '90s to pursue their careers in foreign countries. Among them were Huang Yongping, Chen Zhen, Wang Du, and Hou Hanru in Paris; Cai Guoqiang in Japan; Xu Bing, Zhang Huan, and Ai Weiwei in New York, and so on.

The conception of Chinese art as being unworthy of international attention or unable to

have an "impact on the Western art world" was to quickly change with the increase in international attention on the political and social situation in China. In no time, Chinese contemporary art was embraced by the international art market as a hot item—not particularly for its artistic value, but for its ideological and sociological revelations. In this way, the label of Chinese art became extremely crucial to works that would command international recognition. For many years, even up until today, most Chinese artists, many of whom thrive in the art market, maintain a very strong national identity as compared to a very underdeveloped professional and individual identity. The biggest danger of all would be to then equate one with the other and enjoy artistic success based on identity politics without realizing its true nature.

The fad of buying and exhibiting Chinese art on an international level didn't really speak to the quality of artistic thinking and working in the country, but instead indicated the growing importance of Chinese economic and social power. The consequences of this dimension of the Chinese art world are strongly felt today with the fall of the Chinese art market. It was a necessity of the so-called "cultural multiplicity" that the West was pursuing for their society to help sustain and glorify their global market activities. Chinese contemporary art was simply a souvenir one had to have to showcase one's international lifestyle. But the question of how actual contemporary art practice in China is relevant and valuable to that of the Western world remains unanswered.

Since the 1990s, a newly developed and unconstrained art market took over the Chinese art world as it was still in its infancy, before it had achieved the institutional diversity that

characterizes longer-established art infrastructures in other countries. As a result, contemporary art in China has become almost entirely dependent on market forces, which have set themselves up as the dominant, and virtually the only system of evaluating and crediting artworks and the success of artists. The vibrancy of the market gave a huge boost to the confidence and ambition of the players and fed into the "bigger means better" frenzy. There were bountiful resources available to open galleries of 1,000 square meters, stage expensive productions, mount large-scale exhibitions, produce bulky catalogues, and host luxurious opening-night parties. All of a sudden, everything was possible. Artists responded to such optimism with attempts at mega-productions. Artworks and art practices were discussed and received, not from an artistic and conceptual point of view, but on the basis of misplaced criteria such as size, production budget, market price, and the preferences of collectors.

Concerning artistic production itself, the advancement of contemporary art practice in China hasn't followed the linear logic of Western art history. Intellectual development was basically stagnant and taken hostage by political movements during the preceding decades of Communist rule. This situation worsened with the launch of the Cultural Revolution in 1966, which severed not only the link between the country's intellectual life and the outside world, but also the bloodline that connected it with its own history and cultural traditions. Education was suspended and knowledge and ideas were dismissed.

Thus, when the country reopened its doors and resumed its interest in culture at the end of the 1970s, there was already a great discrepancy between what was going on in the heads of Chinese

artists and intellectuals and what was happening in the rest of the world. Chinese artists rushed to assimilate disjointed and sometimes misinterpreted information and adapted it to the social, historical, and cultural specificity of the country in order to shape their own methodology. Modernism, postmodernism, classical philosophy, eighteenth-century European Enlightenment, liberalism, anti-imperialism, and other intellectual movements from the Western world were introduced into China all at once to become parallel and mixed influences on the practices of artists.

The 1989 "China/Avant-Garde" exhibition can be considered a rather extensive and reliable gauge of the mixture of styles and thinking that contemporary Chinese artists were keenly exploring during the 1980s. All of it, however, was charged with a great sense of randomness, which was telling with regard to the intellectual state of the artists. Their system of knowledge was fragmented. On one hand, they suffered from the missed opportunity for education during the Cultural Revolution and from a missing link to the traditions that were wiped out by it. On the other hand, the sudden shift from having one type of visual and cultural experience (the omnipresent revolutionary realism) to being exposed to a dazzling diversity of aesthetic and conceptual possibilities presented the artists with the challenge of having to decide what to choose. Often the choice was made based upon an instinct or an attitude, and this would become the operational basis on which artists would form their own artistic structure and language.

Although parallel practices continued to exist from the 1990s up to the present day, the international interest and art market have been mostly focused on works that prioritize socially

and politically charged subject matter over stylistic experimentation and conceptual investigation. Artists that created cynical realist, social realist, political Pop that feeds into a kind of collective imagination of a Chinese society have been gaining so much recognition since the early nineties that the artists even strove to minimize technological and formal complexity in order to focus the attention of the viewer on the depicted content. Their method of referring to social content has become the central theme that runs through their entire practice and leaves little room for anything else.

Li Xianting, who wrote the above-quoted letter in 1991, was an important figure in the 1980s whose editorial work in art publications such as *Meishu* (Fine Arts) gave crucial visibility and endorsement to promising young artists and artist groups. It was a time when artists and critics seemed to venture hand-in-hand into completely new territory, later overlooked by the political hype of proceeding years. This new territory involved recovering the normal need to express and experiment artistically without being bound by ideological or political obligations. Formal and conceptual investigations were considered to be a matter of intellectual awakening.

The "China/Avant-Garde" show was less a thematic group exhibition than a platform and occasion, as well as a valid context, for an outburst of emotional and spiritual energy pent up in the previous decades.

Just two years after the "China/Avant-Garde" exhibition, reality seemed much farther away. Contemporary art somehow took a back seat to what the country was occupied primarily with, namely, economic development. There were considerably fewer chances to exhibit publicly within China, and those who had been actively involved in the 1980s

took the time to reflect on building group dynamics and collective ways of working such as through political activism, which offered a source of emotional comfort and courage. Artists and critics were also pondering and searching for a new future in the absence of a clear model to follow. It would take a few more years before the knowledge, understanding, and capital from the Western art structure, along with what Li called "the International system of value," would trickle down to have an effect on the formation of the art system in China.

It was around this time, in 1991, when Li wrote the letter to Fei quoted above. It reflected a rather conservative and functionalist mindset, one that rejected and critiqued the position of those artists and intellectuals who worked outside of China. He attributed the temporary inactivity of Chinese artists residing overseas to the fact that they were outside of their context. Fei pointedly responded by saying that the inability to respond to new contexts was deeply rooted in the education and ideology these artists were subjected to in China, and argued that only when the artists were able to surpass their given cultural and social contexts would they be able to truly succeed internationally. As Fei himself put it:

Most Chinese artists who have left China couldn't fully realize their talents as they did back in China. Besides the issues of language and practical life, the main reason was precisely the particular intellectual quality and way of thinking that were cultivated in their intellectual native land. It prevents them from entering the contemporary cultural issues in a new context. This kind of creative "drought" comes from the inability of these artists to turn what they have learned in their own

country into something that can transcend the cultural gap and continue to be effective. Yet this "inability" is exactly the result of the long-term influence of the closed and conservative cultural spirit unique to Chinese society. Thus, I think what you said might be reversed: "Art must die out without leaving its cultural motherland."

Naturally, what I meant by "leaving" is that art must have a side that transcends its native culture in order to develop. The world today is in the era of globalized culture and openness. We can only truly discover our own uniqueness and enable our native culture to gain momentum by perceiving and being involved in those common issues that transcend culture . . . To reflect on ourselves while keeping the door closed is like a person facing himself in a mirror. No matter how he thinks of himself, it is eventually making himself believe in himself. Although this can be regarded as "sticking to one's native culture," it is actually no more than a self-tortured psychological habit developed in a long-term situation of being closed-minded. In my view, only when the "native culture" walks out of its "native culture," can it become the real "native culture." It's time to reverse what Lu Xun proposed in the thirties, "what is more national is more international" into "what is more international is more national."

What we are doing, and what we want to do, is to gradually place issues brought from the Chinese context into the larger cultural background of the world, in a lively and creative way, so that it can set in motion a process of becoming "common" and "extensive."

There was a great deal of idealist passion as well as critical understanding of one's own cultural context

running through Fei's appeal. Cultural specificity shouldn't be a defining trait of one's existence and thinking; it can however be valuable when placed in an international context to be scrutinized and renewed, in constant interaction and dialogue with an external cultural sphere.

Throughout the past two decades, under the influence of the art market, an infrastructure for contemporary art has slowly taken shape. Yet although it bears all the familiar characteristics of a mature art system—with galleries, contemporary art museums, art magazines, collections, art centers, archives, and so on—a lot of them are just forms without real substance. Art magazines run informational articles, which are rarely critical, and feature neither reviews nor art criticism. Art museums operate by renting out exhibition spaces and filling programs with paying shows, completely lacking in curatorial framework or presentation. Art centers accept shows supported by gallery money or the investment of private art dealers and so-called collectors (who are actually speculators). Art archives and triennials are initiated, funded, and curated by private gallerists who seek to feature their own represented artists in a broader and apparently more authoritative context. Art historians compile bulky histories of contemporary art heavily informed and influenced by their close circle of contacts.

While these roles in the scene are often very blurry, the more profound and problematic aspect is that no matter what motivation or scheme lies behind all of these institutions, the quality of their projects is always the lowest priority, and almost always compromised.

It's interesting to observe this dynamic in the art scene by examining the way Chinese society is

organized. In recent years, the interest in individuality that has arisen from a capitalist economy has met with a strong tradition of surrendering one's own desires to those of a collective situation. Collectivism is about the loss of individual desires, as well as of individual responsibility.

As for the Chinese artists based abroad, it would take longer for them to be recognized. However, the functionalist and results-oriented mentality prevalent in China was also hindering leading critics like Li himself, who was once among those making headway by looking beyond his given reality. Less than two decades later, many of the "exiled" artists who left China to live and work abroad in the 1980s and 90s have gradually returned to major cities in China, many with admirable international careers behind them. More importantly, these figures brought back not only their practice and artistic ideas, updated and shaped by their time overseas, but also a formidable number of possibilities for influencing the art scene within China.

In the case of Zhang Huan, an artist who lived in New York between 1998 and 2005, he had left China for the United States after already gaining prominence in the performance art movement of early-nineties China. Once in New York, it didn't take long for him to be invited to perform and work with important American and international institutions. He proved able not only to overcome the constraint of cultural contexts, but also to transition effortlessly between two cultures, in either direction. In 2005 he moved back to Shanghai and established a fifteen-acre studio and production center on the outskirts of the city. Zhang's continuing international success is the object of envy for many local artists and his way of working has certainly presented a new model for the local art scene.

Here, he hired and trained skilled workers and technicians from various regions across the country, whose technical competence complemented his own thinking. This sophisticated and well-managed production workshop churned out a great number of Zhang's physically imposing oversized sculptures.

Although made in China, Zhang's current works are rarely exhibited inside the country, even though he exhibits actively and sells work on an international level. His first solo exhibition in China, planned last year for the Shanghai Museum of Art, was eventually cancelled due to sensitive content. The last decade of market inflation has given a lot of people false confidence and false belief in the sustainability of the local system. Here the lack of criticality and intellectual scrutiny is replaced by an overemphasis on networking, the forma-tion of personal alliances, and the necessity of strategic maneuvering in order to tease a primitive market appetite. It is this very way of being that characterizes the local art system, which seems to have a hard time finding a way to contextualize, understand, and present the international artistic language and practice of Zhang Huan. He remains an enigma for the art scene in China today.

Meanwhile, many people in the Chinese art scene are still perplexed and constrained by doubts of a general and primitive nature. One afternoon when I walked through the art district of Beijing, the few people I ran into—gallerists, directors of art spaces—coincidentally told me the same thing: now that the market is down, they want to discover new talent and work with young artists. This is as much an illusion as the idea that older and more established artists are no longer active or involved, and have thus lost their value. Like anywhere else, people are obsessed with youth

Carol Yinghua Lu

and emerging talent, yet the difference is that the Chinese art structure hasn't diversified enough to gain the intellectual and theoretical momentum necessary to address the ongoing practice of already established artists and their relevance. The roles of the institutions are not clearly defined and everyone is competing for the same resources, while being simultaneously unable to develop a stable discourse through which to position the actual work.

What Fei Dawei argued almost two decades ago is unfortunately still a valid premise and goal for those of us working in China: how do we examine and activate our own cultural conditions and con-texts in a global discourse, rather than emphasize our own uniqueness and become burdened by it? It's not international attention that will release us, but our self-discipline and critical engagement with our own practices and ideas that will possibly make us active participants in the global art scene, artists who do not lose sight of the rest of the world. Maybe it's less relevant to ask what is "Chinese art" than to think about what is contemporary in our own particular context and how it relates to the larger context of the world.

It seems that we are living in a contemporary world just like everyone else, and we have the same kind of exposure to news and information and entertainment; if we look hard enough, we find that we drink the same kind of coffee and are sensitive to similar kinds of things. But for many of us living in China, it's as if we are only beginning to make the journey to the contemporary. For China, the 1960s and 70s were periods of temporary suspension and removal from the modernist movements—and more importantly, from the transition from the modern to the contemporary—that took place in other parts of the world, and this distance proved

to be devastating. In the past few decades, we have slowly built up a degree of confidence and resources, sufficient perhaps to finally examine the same sets of concerns and issues on the same level, and to finally make the transition to the contemporary.

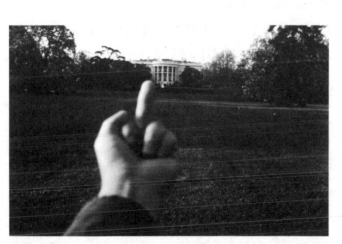

Ai Weiwei, *Study of Perspective - White House,* 1995-2003. b/w-print, edition of 10, 90 x 127 cm. Courtesy the artist and Galerie Urs Meile, Beijing-Lucerne.

Dieter Roelstraete

What Is Not Contemporary Art?: The View from Jena

The View from Jena. Photo courtesy of the author.

Ask not what contemporary art is, but what
contemporary art should be.
—Oksana Pasaiko, 2009

1.

"What is *contemporary* art?" is (clearly) not
the same question as "What is *art*?" The former
basically asks us to define what is particularly "con-
temporary" about art—not, significantly enough,
what is particularly artistic about it. The question
of what is "contemporary" about contemporary art
seems straightforward enough: answering it would
simply require our invoking *all* the art that is being
made now—but of course there is more.

Now, answering the question as to what is
particularly *artistic* about art (contemporary or not)
is famously impossible, and it belongs to the spe-
cific condition of contemporary art (or at least of the
contemporary art *world*, which may or may not be
the same[1])to have made the very act of asking this
question not just impossible, but also unreasonable,
even irresponsible—a show of poor taste or, worse
still, of irreversible disconnect from the daily prac-
tice of (contemporary) art. Contributing to, or par-
ticipating in, something that does not tolerate defi-
nition or other forms of circumscription (so being
part of something that is ultimately unknowable:
not knowing what we're doing) is one of the ways in
which "culture" in general essentially reproduces
itself. This is an important nuance to distinguish, for
it necessarily means that *contemporary* art belongs
to the general field of "culture," whereas art does
not (that is to say, not necessarily). And this, in turn,
is not necessarily a good thing; in fact, it may be a
bad thing. It probably *is* a bad thing. Alain Badiou,
in his introduction to *Saint Paul: The Foundation
of Universalism*, remarks that the contemporary

world is doubly hostile to truth procedures. This hostility betrays itself through nominal occlusions: where the name of a truth procedure should obtain, another, which represses it, holds sway. The name "culture" comes to obliterate that of "art." The word "technology" obliterates the word "science." The word "management" obliterates the word "politics." The word "sexuality" obliterates love. The "culture-technology-management-sexuality" system, which has the immense merit of being homogenous to the market, and all of whose terms designate a category of commercial presentation, constitutes the modern nominal occlusion of the "art-science-politics-love" system, which identifies truth procedures typologically.[2]

It is no coincidence that this poignant lament should start with the fate of *art* (and not, more pre-dictably, with an assessment of the debased status of the political in the contemporary society our fiery Frenchman so tersely describes): Badiou's thought is inscribed in the long history of a philosophical valuation of art above *all* other realms of human activity (even as the singularly humanizing force *in* all of this activity)—a complex history, riddled with contradictions of all sorts, which long ago acquired its canonical form in the heroic figuration of German Idealism.

2.

There are three moments, events, conjectures in the history of philosophy—which is always also/already a history of *art* (in that it is always also/already a history of the *philosophy* of art)—that would undoubtedly make for great, unforgettable movie scenes, maybe even for great, unforgettable movies. In fact, the inevitability of their greatness is probably the one reason why I would want to

entertain the fantasy of venturing into the world of movie-making proper, with or without the help of an artist friend. The first of these scenes would be set in Athens around the time of Socrates' trial; the second one in Jena during the early years of the nineteenth century; the third in Pacific Palisades and neighboring Brentwood during the Second World War. The first scene would feature Socrates himself, of course, along with his heir apparent, Plato, and a motley crew of Atomists, Eleatics, Pythagoreans, Sophists, and the like; in the second scene, such notables as Fichte, Hegel, Novalis, Schelling, Schiller, and (only passing through!) Schleiermacher would appear; in the last scene, Charlie Chaplin would be playing tennis with Sergei Eisenstein while Theodor Adorno and Arnold Schoenberg would be caught bickering over the former's preparatory notes for *Doktor Faustus* at a barbecue hosted by the author of this dodecaphonic novel, Thomas Mann. If a fourth scene were to be called for, it would probably show Plato, Hegel, and Adorno crossing paths on Manhattan's Lower East Side— or in a studio in the Soho of the seventies, perhaps Lawrence Weiner's. (Indeed, it is very tempting to imagine the Soho of the seventies as the last great art-historical equivalent of 1800s Jena.)

So we have called these three high-water marks in the history of philosophy "moments" in the history of art. And surely the scene set in Jena AD 1806 captures the history of philosophy *as* a history of the philosophy of art (and hence also of art proper) at its undisputed acme—a triumphant scaling of the heights after which nothing but the long descent to the banal plains of the "now" could follow. If German Idealism is indeed often referred to as the World Spirit's finest hour, this is in no small measure *because* of the centrality accorded to the

question of art at the very zenith of philosophy's historical development: German Idealism *needed* art to become what it became—or rather, it needed its conceptualization (again, much like Concept Art itself in our beloved, bedeviled twentieth century).

This relationship of inner ("philosophical") necessity and profound dependence is not necessarily one of great love or even sympathy—its roots reach far deeper. Indeed, if one thing is especially noteworthy in this respect, it is the fact that neither the father of German Idealism, Immanuel Kant, nor his talented, rebellious philosophical offspring (Hegel first and foremost, but the now more easily forgotten Friedrich Wilhelm Joseph Schelling certainly occupied a position of similar prominence), were terribly interested in the practical reality of art, let alone very artistically minded themselves. Present-day readers of Kant's *Critique of Judgment* or Hegel's *Aesthetics* will fruitlessly look for passing references to actual artworks produced in their lifetime (certainly of the visual kind), and it is truly frustrating to realize that they were the contemporaries of such iconic image-makers as J. M. W. Turner, Caspar David Friedrich, and Jacques-Louis David, about whose work they remained forbiddingly silent. On the contrary, they were primarily interested in *aesthetics*—but still needed the extremely powerful *idea* of "real" art to lend this primary interest a salient quality, thus shaping a blueprint of sorts for all future engagements of established philosophical practice with artistic practice. [It is far too facile to say that philosophers do not "understand" art, or habitually only "discover" certain artists, art forms, art practices, and/or artworks long after their prime or the moment of their historical emergence/emergency; philosophy's relationship with art is much more complicated than this—while

art's relationship with philosophy is probably much *less* complicated.[3]]

Here follows an extensive quote from Andrzej Warminski's illuminating introduction to Paul de Man's *Aesthetic Ideology*—and we really could not have put it any better:

> For both Kant and Hegel, the investment in the aesthetic as a category capable of withstanding "critique" (in the full Kantian sense) is considerable, for the possibility of their respective systems' being able to close themselves off (i.e., *as* systems) depends on it: in Kant, as a principle of articulation between theoretical and practical reason; in Hegel, as the moment of transition between objective spirit and absolute spirit.... For without an account of reflexive aesthetic judgment in Kant's third *Critique*, not only does the very possibility of the critical philosophy itself get put into question but also the possibility of a bridge between the concepts of freedom and the concepts of nature and necessity, or, as Kant puts it, the possibility of "the transition from our way of thinking in terms of principles of nature to our way of thinking in terms of principles of freedom." ...The project of Kant's third *Critique* and its transcendental grounding of aesthetic judgment has to succeed if there is to be—as "there *must* after all be," says Kant, "it *must* be possible"—"a basis *uniting* (*Grund der Einheit*) the supersensible that underlies nature and that the concept of freedom contains practically"; in other words, if morality is not to turn into a ghost. And Hegel's absolute spirit (*Geist*) and its drive beyond representation (*Vorstellung*) on its long journey back home from the moment of "objective spirit"—that is, the realm of politics and law—to dwell in the prose of

philosophical thought's thinking itself absolutely would also turn into a mere ghost if it were not for its *having passed through* the moment of the aesthetic, its phenomenal appearance in art, "the sensory appearance of the Idea." In other words, it is not a great love of art and beauty that prompts Kant and Hegel to include a consideration of the aesthetic in their systems but rather philo-sophically self-interested reasons. As de Man put it in one of his last seminars, with disarming directness and brutal good humor: "therefore the investment in the aesthetic is considerable—the whole ability of the philosophical discourse to develop as such depends entirely on its ability to develop an adequate aesthetics. This is why both Kant and Hegel, who had little interest in the arts, had to put it in, to make possible the link between real events and philosophical discourse."[4]

I have long liked the fatalist sound of this "had-to-put-it-in" in particular: it speaks to a basic reluctance on the part of philosophy to accept that only one thing is more important ("higher") than phi-losophy, namely, art—the grudging acknowledge-ment (and this grudge may well be the source of all critique) that art, as a very precisely delineated philosophical concept *that is absolutely distinct from the general notion of culture*, is simply the most important thing, namely, that on which all other thinking (including that of "culture") hinges.

3.

Although we have, of course, long since given up any attempts at truly *defining* this thing called "art" (and already in German Idealism it is clear that not so much art as its *concept* is the object of rever-ence and scrutiny, and that it will henceforth be

approached purely negatively[5]),today we continue to live and work, to labor and love, under the aegis of this one tenacious assumption—that art simply *is* the most important thing, and that if a thing is named art, it is thereby made the most important thing, possibly even the only thing. And perhaps this is all the definition we need.

"Art" is not just (*it is in fact far from*) a madding crowd of images, objects, and pictures of objects, nor does its name simply refer to the mass of people who produce the aforementioned; art is not just that which is shown or talked or written about in the various spaces of art, however fleeting or fixed, "solid" or "melting"; and it certainly is not just the subject of art history, art criticism, and/or art curating. Finally, "art" is not just an archipelago of institutions, physical or otherwise, scattered around the world in time as well as space, accruing to a parallel universe that appears more or less disconnected from a supposedly "realer" world down below (or up above, if you still believe in the underground).

It is all of these things put together, for sure, and then some: art is the word, or, better still, the *name* of a great theme, of mankind's greatest idea, its single lasting sentence—the name of a hope and of something that has yet to come: the unfulfilled and/or that which eternally lies ahead. *Not* a thing of the past, then. This, precisely, is where the view from Jena sharpens its focus: like history, science, and society, art is one of the great concepts of "modern" culture—and because we already know what our indifference and careless disregard (posing as "critique") has done to those other concepts, we must forever, and now more than ever, especially in the face of its dissolution in the monochromatic miasma of a "culture" that is no longer so modern,

rally to its defense.[6] We must, in a certain sense, stand up against the gradual encroachment of this generalized culture upon the domain of art—that process of willful confusion that is so characteristic of that which is specifically "contemporary" in contemporary art, namely its very state of confusion (as to its own future, borders, and sense of "belonging").

Imagine that someone would one day say: "there is no such thing as art" (someone else, and someone very powerful too, once said that "there is no such thing as society," and we know now what that has lead to)—now *that* would be very disturbing indeed. *Then* what? What would *we* do, what would *we* talk about, and where would *we* go? Whom would we know and how (on earth) would we ever get to meet them? Let us briefly conjure the image of a truly art-less world, and imagine the panic this would spark, probably very much like the panic a similar prospect or thought would have sparked among the well-read inhabitants of Jena in AD 1806: wouldn't this be much like *the end of the world*?

4.

Let us return to the alarmist, apocalyptic tenor of Alain Badiou's indictment of the "culture-technology-management-sexuality" system as that which has come to occlude the "art-science-politics-love" system. We have already noted how this process of occlusion really goes hand-in-hand with a process of *confusion*—of art's *own* confusion, that is, concerning its relationship to a cultural system (one that used to be called "mass culture" or "popular culture," but those terms have certainly lost their legitimacy) that it clearly desires to be immersed in, or just belong to; a confused desire for its own disappearance into something other, bigger, badder. Now, in thus constructing a one-

dimensionally affirmative relationship (namely one of mimetic desire) with an essentially affirmative cultural complex, contemporary art has become a hugely influential affirmative force in itself—and once again, its insistence on being "contemporary" is precisely what helps to define and determine its affirmative character: not only is it merely "of" the times (the minimal definition of contemporaneity), it basically bestows value upon these times simply by so desperately wanting to infiltrate, inhabit, and if possible even shape it. This great yea-saying ritual is best expressed in contemporary art's reluctance, if not outright refusal—and that is as close as it comes to assuming a programmatic stance—to preclude certain (that is to say, *any*) forms, practices, or tropes from being named art. We have long known that anything and everything can be art, but in our contemporary cultural climate this equation has taken on a different quality, one in which, conversely, contemporary art can be anything and everything. [Or that everything is permitted, to paraphrase Ivan Karamazov.] The critical question then becomes not so much "what is contemporary art?" but, much more typical for contemporary art as such: "what is *not* contemporary art?"

5.

If art does not (or should not) "belong" to culture, or rather belongs to a different, probably *older* order of being (or becoming), and if "culture" is the name of the web of desirous artifice that has come to engulf and wholly cover today's global village (how quaint that phrase already sounds!), then it is probably not too far-fetched to call art, that absent ("occluded") thing such as Badiou and I conceive of it, "a thing of the past"—and here, of course, the Hegelian circle magically closes itself,

for that is precisely why Hegel-the-art-theorist is probably best remembered today: for calling art ("on the side of its highest destiny"[7]) a thing of the past long before art, as we came to know it, came into its own. The view from Jena was already a melancholy backward glance, "theory" or philosophy its only remaining source of solace (and in this sense I certainly continue to reside in Jena *anno* 1806).

But didn't we just call art "the name of a hope and of something that has yet to come: the unfulfilled and/or that which eternally lies ahead"? Indeed we did. Now if art is both (and simultaneously) a thing of the past and a thing of the future, this merely means that there is no art "now"—and that, indeed, is precisely what contemporary art foolishly claims: it wants to be *culture* instead.[8]

This may all sound very grim perhaps—but it really isn't. We just patiently wait for the clouds to clear and the confusion to cease; it won't be long.

The author would like to thank Will Holder and FR David for allowing some of these thoughts, first formulated for the latter, to appear online. I would also like to acknowledge Jørgen Lund from the University of Bergen for sharing some of his beautifully formulated ideas on art (paraphrased in chapter III) with me at a conference organized at the Bergen Kunsthall in August 2009.

1
But I am afraid it *is* the same.

2
Alain Badiou, *Saint Paul: The Foundation of Universalism*, (Stanford: Stanford University Press, 2003), 12. Badiou's identification of art, science, politics, and love as the four fields of human activity that yield truth is a central claim of his philosophical project.

3
There are many reasons for the German Idealists' depreciation of the artistic achievements of their own time, but one reason "why Schelling and Hegel, among others, underrated German art" is particularly noteworthy in the current context: it concerned "their belief that in times of intense artistic creativity . . . there is little reflection on art. Thought about art, and philosophy of art, arise only when art is in decline And Hegel's age was above all an age of criticism and of reflective thought about art." Michael Inwood, introduction to Hegel's *Introductory Lectures on Aesthetics*, trans. Bernard Bosanquet (London: Penguin Books, 1993), xi. Perhaps this remark could help to solve the riddle asked by *Frieze Magazine* on the cover of their September 2009 issue, "Whatever happened to theory?"

Andrzej Warminski, "Introduction: Allegories of Reference," in Paul de Man, *Aesthetic Ideology* (Minneapolis: University of Minnesota Press, 1996), 3–4. The Kant quotation is taken from his *Critique of Judgment*, trans. Werner S. Pluhar (Indianapolis and Cambridge: Hackett Publishing Company, 1987). The concluding quotation by de Man is taken from notes compiled under the title "Aesthetic Theory from Kant to Hegel," delivered in the fall of 1982 at de Man's *alma mater*, Yale.

5

A classic example of the persistence of this *via negativa* in our time is presented by Giorgio Agamben in his essay "Les jugements sur la poésie . . .": "Caught up in laboriously constructing this nothingness"—i.e., the "negative theology" (this is the term Agamben actually uses) of criticism—"we do not notice that in the meantime art has become a planet of which we only see the dark side, and that aesthetic judgment is then nothing other than the *logos*, the reunion of art and its shadow. If we wanted to express this characteristic with a formula, we could write that critical judgment, everywhere and consistently, envelops art in its shadow and thinks art as non-art. It is this "art," that is, a pure shadow, that reigns as a supreme value over the horizon of *terra aesthetica*, and it is likely that we will not be able to get beyond this horizon until we have inquired about the foundation of aesthetic judgment." See *The Man Without Content*, trans. Georgia Albert (Stanford: Stanford University Press, 1999), 43–44. A more elegant proposal, no less negatively worded, however, is formulated by Thierry De Duve in the justly celebrated opening pages of his landmark tome *Kant After Duchamp*, where he invites the reader to imagine herself an anthropologist hailing from outer space trying to figure out what humans mean when they name something, anything "art": "You conclude that the name 'art,' whose immanent meaning still escapes you—indeterminate because overdetermined—perhaps has no other generality than to signify that meaning is possible." See *Kant After Duchamp* (Cambridge, MA: The MIT Press, 1996), 5–6.

6

I am of course perfectly aware of the apparent arbitrariness with which different notions of culture are bandied around and played out against each other here; as is the case with "art," the impossibility of really defining "culture" is partly determined by the culture to which such questions of definition necessarily belong. The question of contemporary culture as that which presently engulfs art and from which, I believe, "art" should be saved, is a central concern of Terry Eagleton's *After Theory* (both Eagleton and his mentor Raymond Williams are, of course, key authors in the art-and-culture debate): "pleasure, desire, art, language, the media, body, gender, ethnicity: a single word to sum all these up would be *culture*." *After Theory* (London: Basic Books, 2004), 39.

7

The reference here is to the following celebrated, oft-quoted (and just as often misread) passage: "In all these respects art is, and remains for us, on the side of its highest destiny, a thing of the past." Hegel, *Introductory Lectures on Aesthetics*, 13. This statement has often been misread as a proclamation of the *end* of art; Hegel himself provides the qualifying commentary, stating that "this claim excludes the possibility of great and/or intellectually authoritative art in the present and the foreseeable future, but not in the distant future. But such an art of the future would not be 'for us.'" Ibid., 105. (It would be "for us," though). The amount of commentary this seemingly casual remark has spawned continues to baffle and astound; Arthur C. Danto and Donald Kuspit are some of this exegetic tradition's most prominent representatives.

8

There is no more powerful symbol of this state of diffusion, which Agamben (see note 5) would describe as "~~art now~~," than the series of books published under the best-selling title "Art Now" by Taschen Verlag.

What Is Contemporary Art?

Jan Verwoert

Standing on the Gates of Hell,
My Services Are Found Wanting

Standing on the gates of hell, my services are found wanting. For I cannot give you what you want. What you want from me, here, on the gates of hell, is to open the gates and let you in. But I cannot do that. I don't even see why that service should still be required. Because you have already passed the gates. You are inside. You live in contemporary hell. You inhabit the hell of the contemporary. And now you want me to perform the rite to confirm your passage? And give you reasons for being in there? I'm sorry, I can't. To grant you a license to be where you are does not lie within my powers. Thus powerless I remain, standing on the gates of hell, observing what passes and sharing my observations with you.

Passing the gates of hell, you get everything you ever wanted. And everything you wanted is all you are ever going to get. Nothing more. Just that. Exactly what you wanted. Everything included. In hell. In a world to reflect your desires, a world coated in surfaces that fracture the light and make its reflections play across the skin of all things new in the modern world, the contemporary world: in a world that stays contemporary by rejuvenating itself in cycles of modernization, with each cycle eclipsing the previous one in accordance with the laws of planned obsolescence. To love this world you must forget all the new you got before, before you now became, again, the new you. The modern world has a lot to offer the new you; each cake it serves you is one to have *and* eat, so that always things can be had both ways: a trip to the moon *and* a journey through the unconscious, a holiday on foreign shores *and* a return home to a country you never knew, an innocence sweeter than raffinated sugar *and* a force brute enough to help you "claw yourself into an untouchable place."[1] All resources that the planet and its people provide—all the oil,

spices, and metals, the power, sex, and money in the world—are at your disposal to fulfill the promise of transcending material needs through material means that modern culture, rendering itself contemporary over and over again, incessantly renews.

Remaining on the gates of hell, I will promise you none of this. I can only tell you there is *more*. No more of *this*. But much more than you have ever wanted before, or thought you deserved. For this too is modernism, of another, an always uncontemporary kind, a nagging doubt and a mocking voice, speaking softly, close to your ear: "What if there was something *more* to life? Than this? Something altogether different, something both/neither old and/nor new, something that was there for you, if only you had the guts to face it…" This is not my voice speaking. But another voice. I only relate what it says. Since I keep hearing it from where I stand, here, on the gates of hell.

1. Uncontemporaries at the Gates

Standing on the gates of hell, I hear other voices. For I find myself in the company of others. In the company of my contemporaries. What makes them my contemporaries is their uncontemporary manners, their mannered ways of causing a disturbance at the gates, their insistence to not readily pass through the gates to enter the contemporary, without reservations. What brings us together, then, as uncontemporary contemporaries—or rather, contemporary uncontemporaries—is not a set of shared beliefs, not a joint endeavor, not a project or enterprise, but just this very intuition: that there is no reason to readily enter, but that it might be more wise to stay on the gates and take a good look.

Standing there, I find myself, for instance, in the company of Irit Rogoff, and I am with her when

she writes that what makes us contemporaries is the act of looking at the problems of our time together and the realization that we share these problems—and maybe not much more apart from these problems—as we inhabit the condition of contemporaneity together. I agree with her in principle. I would contend, however, that facing today's problems together as contemporaries, does not necessarily mean to "fully inhabit and live out contemporaneity."[2] I would rather say that the very act of facing the contemporary, as contemporaries, dissociates us from it—if only ever so slightly—just enough to get the space to take a look and take the time to have a word with each other. This dissociation is not an act of claiming distance, for there is no distance. How could there be any distance to the contemporary, when, as contemporaries, we live today, we are involved, we are entangled! Still, there is a difference in attitude. We do not enter the contemporary readily. We look at it, think about it, and talk about it. We make art about it. We generate philosophy, that is, to invoke the ghost of Nietzsche, a contemporary art of making *unzeitgemäße Betrachtungen*—uncontemporary observations. And we do many other things that demand neither education nor training, things done by all people who hesitate to readily enter (but never hesitate to respond to a distress call from anyone inside) contemporary hell.

Standing on the gates of hell, it is not out of hesitation that we do not readily cross them. Please, don't assume that we are too fickle to make a leap of faith and enter! For this passing requires no leap. The passage through the gates, on the contrary, is a slow process. It is a matter of formalities and technicalities. It is a matter of finding investors, getting permits, and consulting specialists. This is how

you enter hell in a contemporary fashion. Nowadays, it takes time, determination, and patience to go to hell. In these matters we can neither consult nor console you. The formalities and technicalities of the gradual passage to hell are not our field of expertise. We don't pass; we leap. With leaps of thought, we jump from one point of view to the other in order to get a good look at the gates from different perspectives. If you want to picture the gathering of uncontemporary contemporaries on the gates, imagine a swarm of frogs, hopping and bopping around on its threshold. Leaps of thought are leaps of faith, almost by definition. For they presuppose and enact faith in the value of thinking, the value of a particular form of thinking: one that has no immediately realizable use value, that does not readily yield tangible results, that does not generate capital, the kind that you find in philosophy, art, and all forms of care. That value is not recognized inside the gates. So anyone who treasures the freedom of leaping like a frog, in terms of thought and faith, might be advised to stay hopping and bopping around on the gates.

2. Facing the Gates

Standing *on* the gates I say, carefully avoiding the word "outside." Because there is no outside. The whole world is contemporary. It continuously makes itself contemporary in waves upon waves of forceful modernization, of enforced modernization. But there is a limit to modernization, a liminal space to which to withdraw and address the contemporary world that modernization creates. This is the liminal space of artistic intellectual modernisms. It opens up on the limits of the contemporary world. Although it is not entirely outside, it is neither entirely inside the hell of the contemporary. It is

un-contemporary in that it always borders on the contemporary, without ever becoming one with it. It is on the border. It is on the gates. Quite literally so. Look at Rodin's gates. It is on the gates that the picture of life in hell materializes. Hell may itself be full of pictures. But the picture of hell as a whole can only be found on the doors. It is this picture that artistic intellectual modernisms have produced, time and again, on the face of the gates. The stuff of the face of the gates of hell is the material world that the contemporary uncontemporaries of modernity, artists and intellectuals, inhabit and emerge from. Facing the gates of hell, I am amazed by the fact that there are still people here on the gates, and that somehow there always have been. For it must not be taken for granted that there should be any artists and intellectuals—or anyone else who cared, anyone with a heart and a mind—on the face of the gates, facing the gates. Neither is it a given that there is space on the gates. Such lives and spaces must first of all be created through a shared decision and a shared desire to describe, discuss, and remember the hell of the contemporary. It is through this shared decision and desire that the space of artistic intellectual discussion and remembrance opens up. To open up this space is to take a stance. It is to insist that what happens in hell should be exposed to view on the gates. It should not remain hidden behind closed doors. To insist that things should not remain hidden behind closed doors is to take a stance against the customs that govern life inside the gates of hell, the customs of claiming that nothing ever happened, when something did happen, so that business can quickly be continued, as usual. In defiance of these customs, artists and intellectuals insist that the memory, history, experience, and ramifications of life in hell are to

Standing on the Gates of Hell, My Services Are Found Wanting

Jan Verwoert

Auguste Rodin's *The Gates of Hell* exhibited in various places.

be exposed to the public on the face of the doors. The liminal space on the gates of hell, the liminal space of artistic intellectual modernisms and all social forms of care, therefore, is a public space. The insistence on creating space on the gates is the insistence on there having to be a critical public.

3. Weeping and Laughing

Facing the gates of hell, I now take a look around. I ask myself: Where am I? What place is this? This is not Paris. This is not America. Although it could be. This is another place. A particular place. Always another place. And always a particular place. This is because, throughout the last two centuries, various gates of hell have been built in particular places all around the world. And more gates are currently under construction. All these gates are portals to other gates. For all the gates of hell in the world are connected. They are connected through electrical wires, pipelines, and invisible flows of money. But they are also connected through shared ideas and shared feelings of joy and pain. Sometimes the laughter and weeping of people on one gate can be heard on all other gates too, as if the ones who laugh or weep were just on the other side. Upon hearing the sound, some people on the other gates won't be able to help laughing or weeping as well.

Weeping and laughing on the gates of hell, I sense the passage that connects all gates to be a passage in space and time. It is the passage of modernity. It is one global modernity that links all of the gates. Still, each gate is different. Each gate is a pathway to a different modernity, one of many local modernities, one of many pathways to hell. What is shared from gate to gate through the weeping is the memory of all the disasters of modernity, each

different, immeasurable, and beyond comparison, but all modern, all atrociously modern, following the cruel logic of the modern industrialized production of death and injustice. What is also shared through the laughter from gate to gate is the knowledge that the many promises of a better modern world to come were never met, and now seem more like jokes—absurd jokes, serious jokes, jokes that continue to contain a grain of truth. So as we weep today, it is not the end of modernity that we bemoan. Neither do we laugh about it dismissively. This is because the passing of modernity has not concluded. The industrialized production of disaster continues. And promises are still being made.

Weeping and laughing on the gates of hell, I do not feel particularly postmodernist. Postmodernism was neither particularly funny nor sad. We uncontemporary contemporaries, however, are particularly funny and sad. Because we have experienced the fact that history never ended. We have seen the unresolved tensions of modernity erupt in local conflicts, plunging modern countries around the globe back into hell. This is not over. It never was, and it doesn't look like it will end anytime soon. Articulating our contemporary experience, we cannot therefore be anything other than uncontemporary. In our weeping we bemoan the disasters of the past that shape the present in order to try, maybe in vain, to prevent people in the future from repeating them. In our laughter we mock the promises of the past that have become jokes, to be entertained in the present and remind ourselves that, as long as there are still jokes to be made and people to make them, the future cannot possibly be as grim as it sometimes appears. This uncontemporary weeping and laughing, resonating between gates across the space and time of an unfinished modernity, is

the weeping and laughter of contemporary art and thought.

Weeping and laughing on the gates of hell, listening and responding to the weeping and laughter of others, I am surprised to find that I quite often understand why they may weep or laugh. But then, often enough, I sadly do not. This is not because I lack information. It is rather because I sometimes simply cannot fathom what meaning means for people on another gate. Being raised on the gates of northern Protestantism, I was led to believe that to make meaning is to make things clear. This is what meaning means and this is how it is made. Everything is to be made clear. Because it can be made clear. This is quite a promise. Not that I would ever want to fully renounce it. It has potential. But by now it also makes me laugh. A lot. And weep quite a bit, too. Because acting under the assumption that this is what meaning means and that this is how it is made, I have severely misunderstood people on other gates. In the meantime, however, I may have learned one or two things by experiencing art and thinking on other gates. It seems that this is what sharing our experiences on the gates could be about: to grasp, through art and thinking, what meaning means and how meaning is made, on each gate and between them.

Sharing experiences on the gates of hell, we *do* then find ourselves performing some kind of service. We translate what meanings mean and how we experience experience into art and thought. This act of translation is also an act of historical codification. In art and thinking we find the historical codes for understanding what meaning will have meant and how experience will have been experienced. These codes are a key for understanding the joy and pain of life on the gates of hell now,

in the past, and for the future. Similarly, these codes offer access to the logic of neurosis that governs life in hell. The logic of neurosis is always contemporary in that it governs our encounters today. It is also always uncontemporary in that the logic of neurosis doubles as the history of joy and pain, laughter and weeping, as it is inscribed in art and thinking. The service that we artists and intellectuals then find ourselves performing on the gates of hell is similar to that of a storyteller telling ghost stories to children. We tell ghost stories to avow the pain and joy of those who cannot find rest, because inside hell their pain and joy is not avowed. We tell the stories of the ghosts of the past to keep those ghosts alive in the present and give them a future in the memory of our children. We are not afraid of ghosts. The only thing we fear is for there to no longer be any ghosts. For if there are no ghosts, then there is no past and no future, and life on the gates of hell would cease to be possible. Without ghosts there would only be hell. So our service consists of the act of praying for ghosts. As we pray, we invent new incantations and learn historical ones from different gates. Standing on the gates of hell, we invoke each other's ghosts and teach each other prayers.

4. Soul

Standing on the gates of hell, having stood here for a while now, I am forced to admit, once more, that no matter how hard I have tried—and God knows I have tried—my services are still found wanting. Not only can I not give you what you want, neither can I (nor will I) give you what you think you deserve. For getting what you think you deserve is just hell. Everybody in the end always gets what they *think they deserve*. And most people have already gotten it. But they don't like to be reminded

that they have. This is why hell is hell: People are afraid. The two biggest fears are: 1. To get something that one thought one didn't deserve. 2. To then be forced to admit that one already had what one thought one deserved, and that it was bad. So if you want to charm the people in hell and give them what they want, the service you must provide is to relieve those fears. This is done through a simple trick. It is the secret of the trade of true liars: always only give people what they already have and think they deserve. But give it to them in a guise that allows them to rejoice in the illusion that they received something new, foreign, and exciting. This way you don't scare people by offering more than they think they deserve. And you spare them the truth that they already had it all, and that it was bad, since you make the same old seem fresh, right, and justified. If you can perform this trick, you will be loved. For being the fake you are. But you won't go to hell for that. Even if you think you deserve it and want it badly. Because hell won't take you when the devil finds you out. You'll be kicked right out of hell. And end up out here on the gates with us. Bad luck, buddy. Bad luck. So see you around, later.

Standing on the gates of hell, our services, therefore, are found wanting. For we insist on giving more than anyone thinks they deserve. Don't ask me what "more" means. I don't know. This is the point. This is why we linger and leap around on the gates: To talk about what more means, to talk more, think more, and make more art. For only one thing is certain out on the gates: life in hell won't do. There must be more to life than this. A passage to unknown pleasures and a different state of mind. Or just one less lie. One lie less. Maybe it is that simple: As long as there are still people on the gates invested in the idea that there could be more, and therefore talking,

thinking, creating more, there will be more. What for? And for whom? The question is justified. And in line with the faith in there being more than the obvious, it is simply not good enough for the answer to be that it's all just for us, who happen to be invested in this idea. There must be more to this than just that. An uncontemporary proposal that modernist contemporaries have time and again made to gesture towards an answer and offer an alternative to hell on its gates was—not heaven— but the soul, the spirit of a world, or a ghost from a world that transcends the narrow horizon of the contemporary. I concede that this may just be another word for the divine, and therefore just an open gesture towards all that is more than just the given. But I like it for being that. As long as we still, or again, have open gestures to initiate a conversation, an exchange about what more we want, how to find more than what hell has to offer, we will continue talking, thinking, creating, and caring, here on the gates of hell. So my question to you is: What is the soul? What more can the soul be, the contemporary soul, the soul of the contemporary? How can we do things with a bit of soul? And create contemporary forms of thinking, making art and living together that have some soul? Because that would be much better than anything hell has to offer: thoughts and deeds with some soul. Franco Bifo Berardi writes that soul is the peculiar gravity that makes bodies "fall in with others." So let's leap and hop, eager and happy to see the many ways in which we drop in with others . . . [3]

5. Happiness
Saying all this while standing on the gates of hell may make you think that I am a romantic. But I am not. Romance belongs to life in hell. Romance

is exactly what people think they deserve. Nothing more than romance. Life in hell is fully romanticized. Each and every law that governs life in hell is put in place and held in place by romantic pictures and stories. Facing life in hell, standing on the gates, we see it all to clearly. Life in hell is unromanticizable. Because it is already fully romanticized. The last truly romantic act to perform is to acknowledge that life in hell has become impossible to romanticize, and to move on. To something more than just romance. To the love of the body, the love of the soul, and the love of its many ghosts. This is the ethics of an uncompromising dedication to the peculiar material being of others, encountered on the gates. A full dedication to their, your, our happiness. A happiness of the mind, the body, and the soul—and its ghosts. This is hedonism as radical ethics and philosophy proper. As a philosophy and art that becomes the sounding body for the laughter and weeping of many. A philosophy that creates laughter because it is a joke and consoles the weeping because it is a philosophy of tears, a philosophy in tears. This is an art and philosophy that is deeply romantic only in one respect: that it wants more than romance. Another form of happiness.

Standing on the gates hell, facing the gates of hell, laughing and weeping on the gates of hell, I summon you now, my uncontemporary contemporaries, because you have summoned me to come here, to address you. We summon each other all the time. This is how the public space to summon ourselves is created. The space and time to summon the ghosts, the most laughable and saddest ghosts of art and philosophy. This is not an end in itself. The end of the ceremony of summoning the ghosts of art and philosophy is the creation of the space of the public, the space of remembrance, discussion,

laughter, and weeping—on the face of the gates facing the gates. Leaping around like frogs in this space on the gates, we recreate the faith in this space of art and philosophy through our mutual leaps. But this faith, as illusionary as it may seem, is a faith in there being more than just hell. A faith in there perhaps being a body and a soul, and something to share between bodies and souls, something more than we deserve and something more than hell will ever have to offer.

Shanghai, fall 2009

1
I am indebted to Esperanza Rosales for explaining the U.S. to me using this expression.

2
Irit Rogoff, "Unfolding the Critical" (Berlin Tanzkongress, April 2006). See http://www.sarma.be/text.asp?id =1347 (audio).

3
Franco Bifo Berardi, *The Soul At Work* (Los Angeles: Semiotext(e), 2007), 9.

.

Cuauhtémoc Medina

is an art critic, curator, and historian who lives and works in Mexico City. He holds a PhD in Art History and Theory from the University of Essex, UK. Medina is a researcher at the Instituto de Investigaciones Estéticas at the National University of Mexico, and is also a member of Teratoma, a group of curators, critics and anthropologists based in Mexico City. Medina was the first Associate Curator of Latin American Art Collections at Tate Modern in London.

Boris Groys

(1947, East Berlin) is Professor of Aesthetics, Art History, and Media Theory at the Center for Art and Media Karlsruhe and Global Distinguished Professor at New York University. He is the author of many books, including *The Total Art of Stalinism, Ilya Kabakov: The Man Who Flew into Space from His Apartment, Art Power,* and most recently, *The Communist Postscript.*

Raqs Media Collective

(Monica Narula, Jeebesh Bagchi, Shuddhabrata Sengupta) has been variously described as artists, media practitioners, curators, researchers, editors, and catalysts of cultural processes. Their work, which has been exhibited widely in major international spaces and events, locates them squarely along the intersections of contemporary art, historical inquiry, philosophical speculation, research and theory—often taking the form of installations, online and offline media objects, performances and encounters. They live and work in Delhi, based at Sarai, Centre for the Study of Developing Societies, an initiative they co-founded in 2000. They are members of the editorial collective of the *Sarai Reader* series, and have curated "The Rest of Now" and co-curated "Scenarios" for Manifesta 7.

Hans Ulrich Obrist

is a Swiss curator and art critic. In 1993, he founded the Museum Robert Walser and began to run the Migrateurs program at the Musée d'Art Moderne de la Ville de Paris where he served as a curator for contemporary art. In 1996 he co-curated Manifesta 1, the first edition of the roving European biennial of contemporary art. He presently serves as the Co-Director, Exhibitions and Pro-grammes and Director of International Projects at the Serpentine Gallery in London.

Hu Fang

is the artistic director and co-founder of Vitamin Creative Space, a project and gallery space dedicated to contemporary art exchange and to analyzing and combining different forms of contemporary cultures. As a novelist and writer, Hu has published a series of novels including *Shopping Utopia, Sense Training: Theory and Practise,* and *A Spectator.* His recent publication is a collection of fictional essays called *New Arcades (Survival Club, Sensation Fair, and Shansui).* His writing has appeared in Chinese and international art/culture magazines since 1996. His curatorial projects include "Through Popular Expression" (2006); "Xu Tan: Loose" (1996); "Zheng Guogu: My Home is Your Museum" (2005); "Object System: Doing Nothing" (2004). He has been a coordinating edi-tor of *documenta 12 magazines* since 2006. Hu graduated from the Chinese Literature Department of Wuhan University in 1992. He lives and works in Beijing and Guangzhou.

Jörg Heiser

is co-editor of *frieze* magazine and lives in Berlin. He is a guest profes-sor at Kunstuniversität Linz, Austria, and his book *All of a Sudden: Things that Matter in Contemporary Art* was published in 2008 by Sternberg Press. He's a member of the five-piece band La Stampa, which will release an album with the Berlin-based Staatsakt Label in February 2010.

Martha Rosler

is an artist who works with multiple media, including photography, sculpture, video, and installation. Her interests are centered on the public sphere and landscapes of everyday life—actual and virtual—especially as they affect women. Related projects focus on housing, on the one hand, and systems of transportation, on the other. She has long produced works on war and the "national security climate,"

connecting everyday experiences at home with the conduct of war abroad. Other works, from bus tours to sculptural recreations of architectural details, are excavations of history.

Hal Foster

is Townsend Martin '17 Professor of Art and Archaeology at Princeton and co-editor of *October*.

Zdenka Badovinac

has been director of Moderna galerija / the Museum of Modern Art, Ljubljana, since 1993. She has curated numerous exhibitions presenting both Slovenian and international artists, and initiated the first collection of Eastern European art, Moderna galerija's 2000+ Arteast Collection. She has been systematically dealing with the processes of redefining history and the questions of different avant-garde traditions of contemporary art, starting with the exhibition "Body and the East—From the 1960s to the Present" (Moderna galerija, Ljubljana, 1998; Exit Art, New York, 2001). She continued in 2000 with the first public display of the 2000+ Arteast Collection: "2000+ Arteast Collection: The Art of Eastern Europe in Dialogue with the West" (Moderna galerija, 2000); and then with a series of Arteast Exhibitions, mostly at Moderna galerija: "Form-Specific" (2003); "7 Sins: Ljubljana-Moscow" (2004; co-curated with Victor Misiano and Igor Zabel); "Interrupted Histories" (2006); "Arteast Collection 2000+23" (2006); "The Schengen Women" (Galerija Škuc, Ljubljana, part of the *Hosting Moderna galerija!* project, 2008). Her other major projects include "unlimited.nl-3" (DeAppel, Amsterdam, 2000), "(un) gemalt, Sammlung Essl, Kunst der Gegenwart" (Klosterneuburg/Vienna, 2002), "ev+a 2004, Imagine Limerick, Open&Invited" (various exhibition venues, Limerick, 2004); "Democracies/ the Tirana Biennale" (Tirana, 2005). She was Slovenian Commissioner at the Venice Biennale (1993–1997, 2005) and Austrian Commissioner at the Sao Paulo Biennial (2002).

Carol Yinghua Lu

is an independent curator and art writer based in Beijing. She is the co-editor of *Contemporary Art &*

Investment magazine and a frequent contributor to a number of international art magazines such as *frieze*, *Contemporary*, and *Today Art*. Her texts on contemporary art have appeared in many art catalogues, books and magazines. A graduate of the Critical Studies program at the Malmö Art Academy, Lund University, Sweden, she was the China researcher for Asia Art Archive from 2005 to 2007. Her curatorial work includes "The Temperament of Detail" in Red Mansion Foundation, London; "Foreign Objects" in the Project Space of Kunsthalle Wien, Vienna; "The Weight of Reality," Marella Gallery, Beijing; two projects for ARCO'06 and ARCO'07, Madrid; "Community of Taste," the inaugural exhibition of Iberia Center for Contemporary Art, Beijing; "There is No Story to Tell: An Exhibition of International Artists," Tang Contemporary, Beijing. She has co-taught the 2007 summer course for BA and MA art and architecture students from California College of the Arts, acted as art consultant for the Olympic Museum, Lausanne on a major exhibition about China, and is on the selection committee for Pro Helvetia Swiss Arts Council's "China 2008–2010" program.

Dieter Roelstraete

is a curator at the Museum of Contemporary Art of Antwerp (MuHKA) and an editor of *Afterall*; he is also a contributing editor for *A Prior Magazine* and *FR David*, as well as a tutor at the Piet Zwart Institute in Rotterdam and the arts center De Appel in Amsterdam. He lives and works in Berlin.

Jan Verwoert

is an art critic based in Berlin. He is a contributing editor at *frieze* and writes regularly about contemporary art for magazines such as *Afterall* and *Metropolis M*. He teaches in the Fine Arts MA program at the Piet Zwart Institute, Rotterdam.

e-flux journal
What Is Contemporary Art?
ISBN 978-1-934105-10-8

Publisher
Sternberg Press

Editors
Julieta Aranda
Brian Kuan Wood
Anton Vidokle

Design
Jeff Ramsey

Copy editing and proofreading
Orit Gat
Kari Rittenbach
Phillip Stephen Twilley

For further information, contact
journal@e-flux.com
www.e-flux.com/journal

Sternberg Press
Caroline Schneider
Karl-Marx-Allee 78
D-10243 Berlin
1182 Broadway #1602
New York, NY 10001
www.sternberg-press.com